the art of
understanding
art

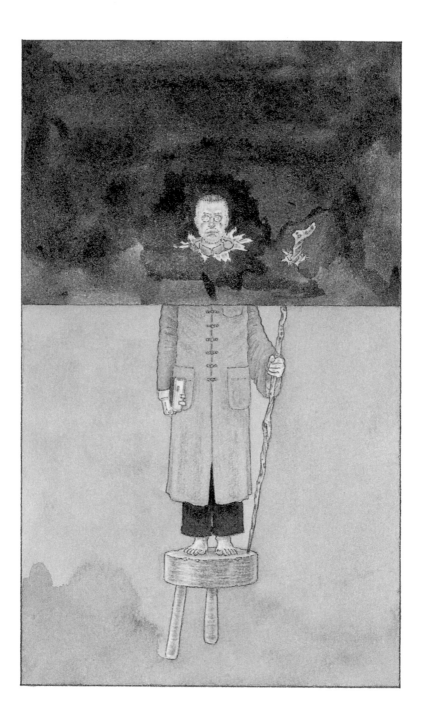

the art of
understanding
art

a new perspective

HUGH MOSS

WITH ILLUSTRATIONS BY PETER SUART

PROFILE BOOKS

First published in Great Britain in 2015 by
Profile Books Ltd
3 Holford Yard
Bevin Way
London WC1X 9HD
www.profilebooks.com

10 9 8 7 6 5 4 3 2 1

A CIP catalogue record for this book is available
from the British Library.

ISBN: 978 1 78125 611 4
eISBN: 978 1 78283 235 5

Text design by Amanda Brookes at Brookes Forty

Typeset in Rotis and Garamond by MacGuru Ltd
info@macguru.org.uk

Printed and bound in Italy by Graphicom

FSC
www.fsc.org
MIX
Paper from
responsible sources
FSC® C013123

To Blossom, Emma-Lee, Rosa-Lee, Robin and Ethan –
beyond the bounds of time

contents

acknowledgements

I am grateful to the many people who have helped refine the evolving manuscript including, to my utter astonishment, my friend Wayne Quasha, the exchanges with whom were not only inspiring but incredibly useful. He prompted a radical adjustment to the initial draft and did so entirely positively, without eviscerating what I was trying to say. Many people who might otherwise have been offended by my now-excised remarks on a wide range of potentially or actually controversial issues have Wayne to thank. Who knew he had such a sensitive nature?

I also owe thanks to those who received an early draft and did not make it past the first page or chapter. That too was an important message. Many of those who did make it through offered suggestions and encouragement, raised questions or otherwise nudged me in interesting directions. They include my daughter, muse and creative mirror Emma-Lee, Professor Sonja Arntzen, Jana Volf, Yifawn Lee of *Orientations* Magazine, Peter Overstall, Jan Thomas, Jenny Moss and Paul Ranjard. The guitar maestro and composer Leo Abrahams confined his brief

response to unqualified admiration – a pleasant surprise for a loose literary cannon attempting a canonical reassessment of the art world.

Peter Suart is one of the world's great illustrators. His masterly paintings for his own series of books for children over the age of 25 (the Tik and Tok series) have delighted me for many years; so much so that I bought all the originals. When my own children are old enough to understand their infinite subtleties, Pete's paintings will be awaiting them. His visual interpretations here have proved equally rewarding. He was also instrumental in refining many of the ideas in the final product.

I am deeply grateful for Sean Geer's calm, expert advice, editing and encouragement. He made it look as if the aforementioned cannon was actually aimed somewhere, then buffed it up to parade-ground appearance ready for the publisher, to whom he also introduced me.

As always, my family has left me in peace to 'get on with it' despite varying concepts of what 'it' might be, and I thank Blossom, Robin, Rosa-Lee and more recently Ethan for filling my life with joy while I get on with, well, filling my life with joy.

Finally, my thanks go to Stephen Brough, Paul Forty and the rest of the team at Profile Books for their enthusiasm, time and patience in nudging the book into existence.

the art of
understanding
art

introduction

Snow covers earth and sky, everything is new
My body is concealed inside a silver world
Suddenly I enter a treasury of light
A place forever free of any trace of dust.

Hanshan Deqing (1546–1623)

The two most important days in your life are the
day you are born and the day you find out why.

Mark Twain

Damn, that's a big lizard.

The Khlongmaster (1983)

In March 1983, I found myself on the prow of a small rented motorboat in a remote canal on the sunset side of the Chao Phraya river, the watery heart of Bangkok. I sat cross-legged on a pile of very comfortable cushions, watching an enormous lizard climb a palm tree as the sun boiled towards the horizon. My regular boat-boy had gone to sleep, crouched over the wheel at the back of the boat. Often on such forays into wonder over the years, the same boat-boy had proved utterly

useless, if equally charming, and as often as not led me up a coalmine of a *khlong* (canal) while the sun set majestically elsewhere, but on this occasion he had got it just right – as if all his previous mishaps had merely been preparation for this one perfect, essential moment.

I was in Bangkok because I had a problem on my hands. As a keen collector of modern Chinese paintings I had become involved in the first symposium on the subject in Hong Kong, scheduled for later that same year. I had been co-opted into putting on an exhibition of my collection, for which I had agreed to write a catalogue, and was in a state of some apprehension about writing this document, as I – a relative beginner, with no formal academic training – would be writing for some of the world's leading art experts, all of whom had accepted their invitations to the symposium. A few days khlonging (messing about in boats) in Bangkok had often cleared the mind in the past, and it seemed worth trying again.

It occurred to me on my boat, as the lizard slowly climbed, that my problem was that I was trying to explain the essence of something that existed far beyond words. What happened then took place faster than I can recount it. Without pausing to think about what I was doing, I decided to imagine sweeping all those wretched little words into the back of my mind and slamming shut a mental door on them. And as soon as I did so *it* happened – the utterly joyous, revelatory, outrageous,

transcendental, full-on experience commonly known as Enlightenment, with an upper-case E.

Astounding as it was, this experience didn't come as a total surprise. Other than a barely adequate but amiably pleasant sojourn at a co-educational boarding school followed by some basic training in business, my background was mostly in oriental rather than western culture. My father had been one of the leading dealers in Chinese art in London in the mid-twentieth century, and Chinese art and books on Chinese art surrounded us at home. By the time my mental boat came home, so to speak, I was familiar with oriental respect for the experience. And as a student, dealer, collector and chronicler of Chinese art for more than twenty years, I was well aware that the Enlightenment experience is at the heart of Daoism (Taoism) and the predominant Chinese and Japanese versions of Buddhism (Chan, Zen).

So I recognised the luminous experience for what it was, and understood its importance. Not just an amazing glimpse, a momentary respite from the real world or some kind of religious revelation; my understanding of what was happening allowed me to enjoy it full-on, in all its glory, as a permanent shift in consciousness that has led to a radical shift in my subsequent approach to art.

I have no idea exactly how long the experience itself lasted in the parallel world of incremental time, but the sun was well above the horizon when I slammed that

mental door shut. By the time I reopened it to allow all those little words to come tumbling back into my head, the sun had set, the night was purple, the stars were twinkling, the lizard had climbed back down its tree and headed for the nearest lizard bar, and I was a 'new man', as the expression goes.

What exactly happened? Well, that's not so easy to explain (although I try to do so in the appendix). But for what must have been more than half an hour, possibly as long as an hour, all those tricky little life questions, the doubt, the what's-it-all-about angst, all those fears and uncertainties, dissolved into a single, infinitely elegant perspective that seemed to be the answer to everything. Not in words, not in fragments, not over time, but as a unified whole.

An analogy might be that my tiny personal computer containing my own limited experiences and under-standing was instantaneously united with its cosmic equivalent – one with the entire consciousness of the universe stored in it. It is very easy to see how such an experience could be interpreted as an audience with God, if you were religiously inclined and were prepared to believe that He had personally selected you for His purpose. That could easily unbalance an overreaching ego. Fortunately my pleasantly inadequate education was religious only in the sense that the school had a chapel – used mostly, as far as I was concerned, for xylophone

practice (don't ask) and making out with girls, since it was one of the few places in the entire school where you could be reasonably certain of not being disturbed – other than occasionally on a Sunday morning.

It would be all too easy to come back from that moment of luminosity and overlay it with all sorts of socio-cultural prejudice. You could dive into the memory of that light the moment it was over, rip it apart, and come out dressed as an angel. All I did, though, was burst into tears of joy as I began to process the extraordinary new insight and perspective that suddenly made utter sense of everything I had ever doubted and experienced. I went home a couple of days later and banged out the catalogue in a week. It was no longer a problem; the pressure was off and no fear remained. I just picked the paintings I liked best, and said what I felt like saying about them.

That moment informs my life still, and has led directly to the theory of art I propose in this book. Applying the experience to my approach to art has proved revelatory. I had been puzzled, along with so many at the time, by what was going on in western art, but was also at a loss to explain the obvious 'modernity' of many aspects of the ancient Chinese art that so intrigued me. The art theories I sought out, East and West, seemed inadequate. My experience on the *khlong*s prompted a breakthrough, suggesting an entirely new approach – among much else,

linking art to its role in the evolution of consciousness as a fundamental plank of art theory.

As a form of communication, apart from its other roles, it seems to me that art should be regarded as a primary, autonomous vehicle in the evolution of consciousness, alongside religion, philosophy and science – rather than one subservient to those disciplines, as it had been in the West until the modern revolution which so excitingly transformed the nature of western art from the late nineteenth century into the second half of the twentieth. At the same time, art's role in this revolution also needs re-examining. I think we have made the mistake of taking the skirmishes in the modern western revolution for the revolution itself, thereby missing the point of it and becoming horribly confused in the process. All the '-isms' – impressionism, cubism, abstractionism, expressionism, abstract expressionism, minimalism – are not the revolution; they are simply expressions of the new-found freedom for art as an autonomous vehicle, rather than a slave to grander pursuits. It is that very freeing of art to become an autonomous vehicle in the evolution of consciousness that is the revolution.

Approached like this, art is empowered in all sorts of new and exciting ways. The theory proposed here is, in some ways, as radical and alarming as the art that led to it. Whether or not you subscribe to all its details, it's probably not overstretching to claim that there is

something about art, about the creative urge and the need to express vision, that carries something of vaster importance to us than we can explain. So I'm going to try to explain it.

1

out of the frame

There is only one way to see things,
until someone shows us how to look at them
with different eyes.

Pablo Picasso

The artistic revolution that arose in Europe and America and took the world by storm in the twentieth century has led us into brave new worlds of perception and expression. Anyone reasonably conversant with the art world – that infinite playground for the mind, heart and soul where creativity is oxygen, reality elastic, and wealth grows like mushrooms – now accepts the new, vastly expanded horizons of art. Silent music, wrapped bridges, a blank white canvas, an unplumbed urinal, a neat pile of bricks on the floor of the Tate Gallery, or Tracey Emin's unmade bed – all are now recognised as art.

The initial response to such works was confusion, denial, dismissal and a great deal of confrontation between art experts. Today, though, the art world has moved on. These once-controversial icons have been

discussed so often they have become clichés; even to mention them raises yawns, or mutterings of 'Oh, do get over it. We've dealt with all that. We get it! It's art!' Well, yes we have, but the reason I bring them up again is because I don't believe we have yet understood their underlying meaning. We've only 'dealt with all that' at the most superficial level – accepting that they are art. If we *really* understood their significance and their role in changing the nature of our approach to art in general, there wouldn't be so many people still puzzled by their status. And there can be no doubt that many are still sceptical, even if they are either outside or at the fringes of the art world; marginalised, standing bemused in the ruins of yesterday's dogma, scratching their heads and still muttering disapproval. Surely if we have truly 'dealt with all that', there would be broader agreement, not to mention less muttering. One problem is that while the art and the way we approach it has changed, our theoretical response to it has failed to keep pace, and so remains inadequate.

There is nothing unusual about this. In the arts, theory and creative practice are the two main vehicles of progress, but in times of radical change, practice tends to assume the vanguard and theory is left to figure it all out later in the obfuscating dust of its wake. Three fairly recent examples of such obfuscation (in art-world terms, at least) exemplify exactly this trend.

- Grayson Perry, the 2003 Turner Prize winner who describes himself both as an 'Essex transvestite potter' and part of the 'artworld mafia', wrote an enormously entertaining and readable book entitled *Playing to the Gallery*, published in 2014. It directly addresses the confusion faced today by those who try to judge art, and its obvious appeal is reflected in its sales figures. Still, he demonstrates the common failure to understand the fundamental message of the modern western revolution in the arts with a continuing focus on judging the art objects as the end-product of art. There are some handy and amusing recommendations, but they hover at the surface of the problem faced by the bemused, rather than addressing the Gordian Knot of confusion that is the modern art world.

- When the Tories were in opposition in 2004, Boris Johnson was moved to the front benches as shadow minister for the arts – a fact that might lead one to assume that he had been chosen because he knew a bit about them. He soon contradicted this assumption by suggesting various measures he would put in place when in government, one of which was this: 'We are going to convene a summit with Damien Hirst and the rest of the gang at which they are going to explain to the nation what it all

means. Let us have a national "mission to explain" by the Saatchi mob ...' It seems that the Tory arts minister-in-waiting, one of the best-educated and finer minds in government, was as puzzled as many others about today's art.

- Henry Moore's daughter Mary, speaking in early 2015 before a major exhibition of her father's works at the Yorkshire Sculpture Park, also picked on Hirst, claiming that he had set art back by a century. She said that her father had challenged the narrative and formally presented artwork of the Victorian era. 'What he did was come along and take it out of the frame in a very weird way,' she told the *Guardian*; 'I think Damien Hirst put it back in the bloody frame and what you forget is how radical it is that it's not in the frame.' Her issue with the work of Hirst and others was that it relied on its title and the cube it was in, as she put it. It was, she suggested, much more about having to read the label to know what was going on. This was, like so much art-theoretical opinion of the past century, a battle of the '-isms'. It completely misses the point of the artistic revolution and its fundamental achievement in favour of fighting over surface details – 'Never mind the picture, let's roll up our sleeves and slug it out over the frame!'

And so the confusion continues. Even if we have accepted the unplumbed urinal, silent music, wrapped buildings and unmade beds as art, there is still obviously a great deal of misapprehension out there about art in general and modern western art in particular. Uncountable responses on the internet to art projects and proposals, existing art objects and even art critics all demonstrate beyond a doubt that we are as yet a very long way from broad acceptance of the new realms of art. The big question is this: is there any point in even trying to achieve this kind of acceptance? I think so; hence this book, which I hope will provoke debate and stimulate discussion among both artists and audiences. I hope that it is entertaining and approachable enough to be worth reading for those reasons alone. For those wondering whether or not they actually *need* to read this book, your answers to the following questions may help to resolve the matter:

- Accepting that we have witnessed a recent revolution in the arts in the West and that a revolution is against *something* – some perceived tyranny – what was the underlying tyranny that needed overthrowing? What, fundamentally, were the artists revolting *against*?

- Revolution cannot, by definition, be a permanent state, despite the dreams of Marx and Mao. Has it ended yet? If so, when?

- What has been achieved? Not just this or that work of art, but what has been fundamentally achieved for our culture and consciousness?

- Was this revolution merely a western phenomenon? If it was a revolution against something, and it has achieved its end, did other cultures similarly need to revolt against the same perceived tyranny? Has any other culture achieved the same underlying revolutionary ends? If so, when – before, or as a response to what took place in the West?

- Why do we treat art and artists with ever-increasing respect? Why are museums the cathedrals of our time, packed with the flocking humanity that once filled churches now offering up hushed, devotional reverence to Art rather than God?

If any of these questions remain even slightly puzzling, then this book is written for you. (Well, actually it was written for *me*, since I have always found that attempting to write about something is by far the best way to get to grips with it, but, as Willie Nelson sang: you were always on my mind.)

It seems we are suffering a serious art-theoretical lapse. In the many books and articles I have consulted on art theory, I find no overarching theoretical perspective on art to match the radical changes wrought by artists. Of

the theoretical writings that do exist, many for the past half-century devoted their discourse to whether or not, in the face of modern art, it is even *possible* to have a theory of art – a telling debate that reveals the fundamental failure of theory to match the art it is dealing with, the reasons for which I address below. Many others focus on one movement, one '-ism' or another, rather than art as a whole, and most get so bogged down in semantic details that they go round and round in circles only to disappear up their own dictionaries. In any case, many of them are unapproachable without a Ph.D in philosophy.

What I propose resolves all these outstanding questions, identifies the underlying nature of the recent western revolution in the arts, and places it sensibly in the context of world art – with some rather surprising and, to some, doubtless shocking results. It is also a theory of art which can be equally applied to any art from any culture at any time – which would seem to me to be a prerequisite for a theory of art, but which is singularly absent from any publications I have yet discovered.

One big problem that presents itself in trying to explain what art is all about is that many people simply don't look upon art as something you need to learn about at any fundamental level. Art *history*, perhaps; but art itself rarely seems like a subject for study in such depth and breadth. In the same way that anyone can listen to music without any instruction and become deeply

involved, there is a tendency to feel that anyone can look at a painting or sculpture, or enjoy a theatrical performance, without any need for guidance. This is another expression of an old chestnut: 'I don't know anything about art, but I know what I like,' usually a proudly self-sufficient indication of ignorance. (This is a particularly strange conviction, since the same people will allow that the artists themselves – the people who create the music, paintings or performances they approach with such self-sufficient confidence – *did* have to learn a great deal in order to produce them.)

The truth is that while the arts are broadly accessible to all, some more than others, there is an enormous amount that can be learned in order to delve more deeply into the experience of art and benefit more fully from it. Nor is it a chore. Learning how to approach art is not a matter of detailed study and correlation – all that is needed are a few theoretical shifts in our view of how art works and how to approach it. These can be grasped in revelatory leaps and bounds as part of an adventure – mind-surfing, rather than hard work. Let's get started.

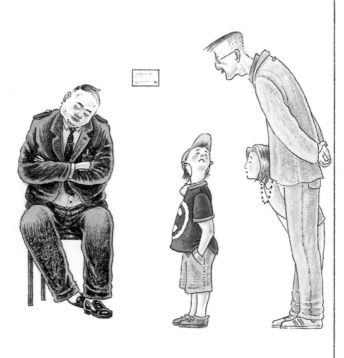

2

pass the theory

We are all agreed that your theory is crazy. The
question that divides us is whether it is crazy
enough to have a chance of being correct.

*Niels Bohr to Wolfgang Pauli, after a presentation
of Pauli and Heisenberg's nonlinear field
theory of elementary particles in 1958*

No artist is ahead of his time. He is his time;
it's just that others are behind the times.

Martha Graham

If you were to stroll around a contemporary art fair a
couple of hours before opening time, you would be
forgiven for occasionally confusing the exhibits with
the random 'installations' of fair paraphernalia – crates,
rolls of carpet, fork-lift trucks, step-ladders and burly
guys decked out with tool belts and gaffer-tape. Okay, I
concede that the guys with the tool-belts would be no
problem; but what if you were to put one on a pedestal,
spotlight him, and add a label for the opening? Drive the
fork-lift onto the stand and label it with an artist's name
and a title – 'This is a Fork-lift Truck', perhaps (or if you

want to be enigmatic, 'This is *Not* a Fork-lift Truck') – hey presto! It becomes art.

This is much less flippant than it sounds. In early 2015 I visited the opening of Art Central in Hong Kong, a newly established contemporary fair, where a gleaming, dark blue Lambretta motor scooter was on its stand against a blank wall, a pile of freshly printed catalogues set on its chromed rear rack. It was, in fact, an unusually clean and gleaming delivery vehicle for tardy catalogues, but while admiring it as an icon of my youth, I noticed several people who stopped to seek out its label. Two of them even took photographs of it. It looked every bit as legitimate an exhibit as the other works of art on show, lacking only a label to identify it as such.

And why not? Marcel Duchamp's reinvented urinal, entitled *Fountain,* remains one of the most iconic works of art of the twentieth century. In 2004, some 500 artists and historians voted it the most influential art work of the century. The main differences between it as a work of art and as a functional pissoir were orientation, environment, plumbing and a label (albeit under the pseudonym R. Mutt). I would have been tempted to plumb it in, since the critics were initially bound to piss all over it, however much they would change their minds by 2004 – and in fact, several artists have attempted (and in some cases, such as Brian Eno, apparently succeeded) to do exactly this over the years. Indeed, the massively

negative reaction to its elevation to art-icon of the century promptly demonstrated that most people still did not understand it as art, nor its significance in our artistic revolution, nearly a century after it first shocked the art world. (I think my favourite online commenter's response, from someone called Graham, was this: 'Finally, a piece of modern art ready to receive my opinion of it.' Graham, may I introduce you to Boris?)

Today we routinely include a far broader range of activities in our expanded definition of the arts than would have been accepted a century ago. We now entertain a seemingly limitless range of endeavours as art that baffled and infuriated earlier generations. Questioning Tracey's bed as art risks revealing oneself as something of a philistine. It *is* art. It works as art, it has been accepted as art, viewed and considered by aesthetically hungry hordes as art. When it was sold at auction by Christie's in July 2014, it made £2.54 million. Sounds like art to me.●

We don't need an ironing board and maid service to

● When I owned a gallery in Bruton Street in London's artistically fashionable West End dealing in, amongst other things, modern Chinese paintings long before anyone cared (the early 1970s), a friend once gave me a cartoon to hang over my desk showing a gallerist standing in front of a painting. The caption read: 'Any fool can paint a picture, but selling it – now that's art!'

sort out *My Bed*. What we need instead is a theory of the arts for our modern age that makes sense not just of Tracey's bed, but of how it fits into the broader field of art; and not just modern and western art but *any* art, from any culture, at any time. Indeed, it is high time we stopped to consider how the western revolution fits into the broader, pan-cultural art world. It should also be a theory that can be understood by all those who remain utterly bewildered by a great deal of modern art; and preferably one not couched in such terms as

> *Any attempt to transform autonomy into a transhistorical, if not ontological precondition of aesthetic experience, however, is profoundly problematic.*

This sentence appeared in a theoretical work aimed at *informing* undergraduates. Perhaps it was intended as a filtering system of some sort; if, armed with a good dictionary and plenty of time, they could work out what that means, they could stay on the course.

There is a good reason for the absence of an over-arching theory, and it is the same reason that explains why we spent fifty years arguing whether or not such a theory is even possible. What happened was that while the sphere of art expanded exponentially to become more and more inclusive, the sphere of art theory remained exclusive: a separate, confined discipline that was the

domain of philosophers and critics. Art had broken out of its bonds to become a far more deeply ingrained part of life and consciousness, while art theory had not; it was still missing the fundamental point of the revolution, trying to deal with a vastly expanded horizon, but stuck within the same limited historical framework. So a credible universal theory of art had, quite rightly, become questionable; or at best, inadequate.

One overwhelmingly prevalent feature of our earlier approach to art in the West was that we fostered the illusion that the art object itself was the end product of art, and that the artist's vision and technique in creating it were the basis of the overall process. The audience was a secondary consideration – separate observers, mere spectators on the sidelines. One of the fundamental modern shifts is the realisation this was never possible, and that the object was just part of a broader process of art; a process that includes the artist on one side of the physical art object and the audience on the other, linked by a mass of infinitely flexible meaning.

Despite its inherently fallacious nature, the earlier illusion allowed us to isolate the art object in order to decide whether or not *it* was art. As a legacy of that, we still tend to approach art theory as if it, too, can be dealt with separately. This suggests to me that to arrive at a useful and universally applicable theory of art, it is time to reach beyond the art objects themselves into the

art process, and embed the whole thing in a theory of evolving consciousness.

Art functions in our lives at many different levels, from the banal to the highly sophisticated. But these functions are what arise out of art; they do not define it. They tell us little about the true nature of one of our most sophisticated means of perception and expression – a means of communication with the self and with others in a range of languages which are capable of transcending the verbal. Victor Hugo summed this up neatly in relation to music: 'Music expresses that which cannot be put into words and that which cannot remain silent.' These subtler, non-verbal languages are essential to sustaining and raising our levels of consciousness, something which human intelligence is constantly seeking to do by all the means at its disposal.

Crucially, of course, art is also a highly sophisticated storage system for understanding, allowing communication with cultures and ideas to take place over long periods of time. Without our literature, paintings, architecture, music and a host of other arts, we would remain primitive, forced to learn the same things over and over again with each generation. Creative endeavours are the bedrock of culture.

Any universal theory of art, then, should take into account its role in raising consciousness. Linking art and consciousness illuminates not just the nature and process

of art, but the process of the evolution of consciousness too. It gives us a more sensible framework for understanding clearly what art is, why we need it and how it works. It is an essential theoretical shift if we are to fully understand not just modern western art, but art from every other time and place too.

The overall theory will emerge from the following chapters bit by bit, and will not necessarily mean the same for everyone at every level, but I hope that it will make some kind of sense to everyone – even if the theory itself shimmers a little at the edges and you can't quite nail it to a wall. It should allow a good deal of modern art to be trimmed off and relegated to its rightful place as aesthetically adolescent ramblings (although there is, as we shall also see, a place for that), while enabling its upper end to be mined more productively for its transformative capacity. The real benefit, though, is that we will have the tools to help us to judge the difference between the banal and the sage, which will take the confusion out of both modern art fare and the modern art fair.

3

the fourth pillar

Not everything has a name. Some things
lead us into a realm beyond words.

Aleksandr Solzhenitsyn

It barely needs saying that the functions of art are manifold. At the lowest level, art's job can be extremely banal; matching the drapes, or filling large blank wall spaces with something decorative. However prosaic these roles may seem, it is nonetheless worth pointing out that both of these are forms of communication with an audience, albeit low-level ones: they convey the desire to decorate, and indicate a specific taste in doing so. From these base levels of communication, there is an almost infinite journey upwards. Art informs as it inspires, as we move from one level to the next. A blank wall tends not to lift your spirits when you come home from a hard day at the office. A painting which has meaning for us gives us a boost. It enhances our home life and, thereby, life in general. Art reminds us of ideas through subject matter and symbolism. It communicates dynamism and balance, control and abandon, confidence

and sagacity – all positive, life-enhancing facets of the human condition.

But art also acts as efficient social grease. Many are the mega-wealthy who earned, and continue to earn, their place in society more through the civilising vehicle of their collections of costly and impressive art than for their fascinating conversation and good table manners. Art opens doors, but it does far more than that: it cultivates and educates as it grants access to ever loftier salons of society and intellectual exchange. Even the most boorish railroad barons, mining magnates and hedge-fund billionaires may throw money at good taste and social acceptance, but in doing so they actually *acquire* good taste and *become* socially acceptable, not just because they have art, but because the art civilises and informs them efficiently and rapidly. Art is enlightening, because it draws us in, communicates, educates, and hones our taste and connoisseurship. And of course, it is not just an investment in social acceptance and self-improvement; it can also be a terrific financial investment if pursued knowledgeably and wisely.

We communicate with our arts at every level, far beyond any initial intention by the artist to communicate something specific. In painting, for example, that communication happens in many ways – through immediately obvious subject matter or the more subtle inner languages of art, such as form, line, colour and texture.

Underlying those are still more subtle languages, such as confidence and even wisdom. We may look at a Jackson Pollock and admire the linear complexity, the expressionistic verve, but what holds all that together and is so utterly compelling is his complete confidence in *how* he produced his symphonies of expressionistic line. We read the language of line that is so integral a force in his later works, but we also read the confidence; it inevitably informs us in our own lives to some extent, however subliminally. (This may prove especially crucial if you are an artist and can somehow master such confidence in your own work, of course). All those languages of art inform and civilise us in so many ways. They are the cornerstones of culture, the crux of consciousness. We ignore them at our peril.

Ultimately, art does not, *cannot* stand alone. It is a vital part of how we evolve as an intelligent species. An exciting possibility arising out of linking art theory to a theory of consciousness is the potential to also link in the other three primary vehicles of that evolution (science, philosophy and religion); a theory of everything, no less. Wouldn't it be a surprise to see that coming out of the art world rather than from physics? Of the four, art defined at an all-encompassing level of 'any creative response to experience' is the only one that is capable of subsuming the others.

Creativity can be considered the most important

force at work in the universe. Accepting – as I do – the Big Bang as the most convincing current theory of how the universe began, the energy from that event created our universe and everything in it, and continues to fuel that creativity. In this sense, energy is a fundamentally creative force that underpins everything we can perceive, including our own intelligence and consciousness. So it would seem to make sense to see it as the unifying aspect of all our endeavours. Creativity – which more or less defines art – is better able to subsume religion, science and philosophy, all of which are essentially creative endeavours, than any of the three is able to subsume art.

For a very long time, we have managed to convince ourselves of quite the reverse in the West. For centuries, art was subsumed by the other three principal disciplines; until very recently, it was treated as wholly subservient to religion, philosophy and science, an afterthought or a footnote to their grander narratives. And *that* is the underlying tyranny that our modern revolution overthrew. It wasn't the shift from subject matter to abstraction, or from one way of viewing the world to another, that was the revolution – those were just skirmishes caused by it. The underlying revolution was against intellectual tyranny, and its subjugation of what should have been an emancipated, autonomous pursuit. Grasp that, and all modern art suddenly becomes accessible.

Art's subservience took many different forms. Its

servitude to religion is particularly obvious, as witnessed by uncountable portraits of the Virgin Mary and child by western artists, among much else. But that servitude has if anything been reversed, and art has been famously described as 'the new religion'. Until a century or so ago the thronging, aspirant hordes would go to cathedrals, among the most outstanding and outrageous buildings of their day, and enter in hushed, reverential awe. Today they go to museums, among the most outstanding and outrageous buildings of *our* day, and enter in hushed, reverential awe (okay, perhaps not the bussed-in school children; but even kids tend to shift automatically to a level of 'best behaviour' they wouldn't consider on the streets or in the playground once they step into the hallowed halls of a museum or gallery).

As consciousness evolves, religion tends to hold less sway over our lives. Multiple gods tend to give way to a single god, who then gradually fades from personality, kicking off his sandals and morphing into some more distant concept of spirit, or source. Richard Dawkins summed up his atheism with a telling remark in this respect: 'We are all atheists about most of the gods that societies have ever believed in. Some of us just go one god further.' Darwin famously pierced the theoretical foundations of western religions, calling the very edifice of faith into question for many.

As religion recedes in importance, as it has done in

so many cultures in the last century, our relationship with its figureheads changes. We begin to understand prophets and the priesthood as hopefully well-meaning interpreters of some higher order, rather than as authority figures bringing us precise instructions from some meta-individual on high with a rather alarming personality. Many become suspicious of the more rabid interpretations and demands of the radically religious, with their espousal of violent death as a viable debating technique. The power of the priesthood over more sophisticated consciousness fades, while the power of artistic vision grows.

It is no surprise, then, that we listen with rapt attention to what artists (and their interpreters) have to say, granting them the reverence we once granted the priesthood. It's a *vision* thing. Artists are associated with that creative vision – that capacity to see and comprehend things that ordinary mortals cannot – so they become the new prophets, the new priesthood, along with critics, curators, academics, gallerists; anyone, in short, who can explain it all to us and help us understand the mysteries of the universe. This doesn't make the new, aesthetic priesthood any better or wiser than the old religious priesthood, as the artspeak that babbles forth from art exhibition catalogues demonstrates (although it does provide some of the most entertaining reading in the art world). It is well worth noting, however, in this

shift from gods to artists – or, more accurately, from the religious approach to the individually creative approach – that as a rule, artists do not tend to exclaim, 'He's using cerulean blue! Heretic!' That is, I think, a step in the right direction.

Art's servitude to philosophy is represented by portraits of the great and good, battle scenes, still-life subjects representing the subjugation of nature, and so on; all representative, in some manner, of philosophical beliefs. The servitude to science is less obvious but more pervasive, and rests in the long-standing preference, until quite recently, for objective reality (and, therefore, recognisable subject matter) as the basis for art. Yet here, too, we see inescapable parallels. Science is highly creative, even if the empirical method is ultimately key to it. Even that is up for discussion now, however, with a whole school of eminent scientists suggesting that we expand its borders to include elegant hypotheses even if they can never be proven, such as the multiverse concept. Scientists creatively ponder every aspect of the universe, create often highly inventive means of testing their ideas, and design and build astonishing equipment to do so. Einstein himself described creativity as 'intelligence having fun'. To undertake science in the first place is a fundamentally creative activity: 'Hey! Those things up in the sky, this stuff under our feet – why? Let's figure it all out.' Working out which questions to ask, and why

they're important, is one of the principal markers of our evolution into a conscious, creative species.

In the past century in the West, then, art has broken free of its reins. It has finally taken its rightful place alongside the other three vehicles driving the evolution of consciousness; freed to perform a leading role, rather than forced to hover politely at the banquet of religion, philosophy and science before being sent away to wash the dishes. That emancipation underlies our modern revolution, and it was a genuine revolution; a revolution against the tyranny of the intellect that had subtly and gradually forced art into servitude in the West. It was not the intellect itself that artists objected to; they could not have been either intelligent beings or artists without it. Instead, it was the overreaching intellect believing in its own autonomy and authority – the Intellectual Tyrant – that was the threat.

Our modern revolution overcame this tyrant. It set free the languages of the visual, musical and theatrical arts, and gave them independence. Had Leonardo da Vinci put a few bold, black strokes on a canvas, everyone would have assumed he was cleaning his brushes and waited for the real painting to begin; but when Franz Kline or Robert Motherwell did it, it was art. We weren't ready for such emancipated expression then; we are now. Consciousness has evolved.

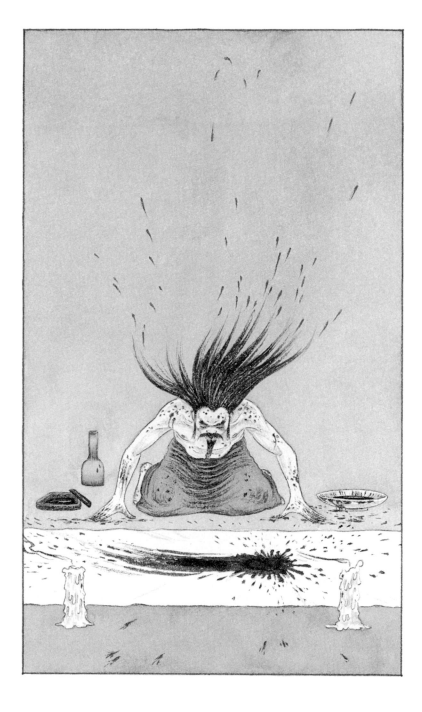

4

the aesthetic divide

Art is a step from what is obvious and well-
known toward what is arcane and concealed.

Kahlil Gibran

In the previous chapters, I have stressed the western-
centric view of art in the past century or so for a very
good reason. One of the problems we must overcome
in constructing a new theory of all art is the casual ethno-
centricity of the old one as it evolved under the yoke of the
hegemonic West. Because the West so nearly conquered
the physical world with its technological supremacy at
just the moment that its excitingly different art began to
take the art world by storm, we jumped to the conclusion
that its arts too must be leading the world – that Picasso
et al. were a sort of aesthetic parallel to nuclear weapons.
We automatically assumed that western modern art was
the cutting edge of global art – where it's at, both literally
and metaphorically.

Much as many in the West would like to cling to that
illusion, it is just that – an illusion. In Chinese culture,
art has been fully emancipated for centuries. This artistic

emancipation was a result of two important beliefs: firstly, that the transcendental state of consciousness (more on this later) was the all-governing state of being; and secondly, that art was a powerful vehicle in achieving that transcendence. It is true that Oriental art was influential in our modern western revolution; but only for its surface appeal, not for any deeper understanding of what it implied in art-theoretical terms. The West was too busy patting itself on the back about its own art to do more than borrow a few surface hints from anywhere east of the Black Sea.

So it may come as a bit of a shock to discover that all of the underlying tenets of our revolution were foreshadowed in China between the sixth century BCE and the fourteenth century CE. This is why I use Chinese art throughout this book as a useful counterpoint to western art; because of its aesthetic precocity, as well as its cultural longevity and continuity. (Note that the intention is not to marginalise the art of any other cultures; it is to provide a framework for understanding them all without the inevitable diversion of addressing all world cultures equally. This book is not intended as a guide to world art, but as a guide to the underlying nature of art, which is universally applicable.)

Silent music is a good example of China's artistic precocity. It was broached as a subject for aesthetic discussion as early as the time of Confucius, in the sixth

century BCE. By the time of the Song dynasty in the twelfth century, it was not only a part of art theory but one that was well understood; something we can barely claim in the West even now, nearly 100 years after Erwin Schulhoff's *In futurum* and more than 60 years since John Cage's infamous *4'33"*.

The inner languages of visual art were fully emancipated between the fourth and fourteenth centuries CE. Ink-play, where random abstract markings were made on paper and then interpreted, is a long-standing genre in Chinese painting, to the point where we are told of a Tang dynasty (618–906 CE) artist who experimented with throwing a brushful of ink over his shoulder at a sheet of paper. Painting things the way they looked (objective reality) was already considered a childish pursuit by the twelfth century. So why does this 'modern' ancient Chinese art not resemble our modern western art? Well, the fact is that it does – *but not on the surface*. We need to learn not just how to look at it, but how to *see* it.

Paradoxically, the scientifically dominated western mind tended to approach even its revolution to break free of the domination of science in a thoroughly scientific manner. It first set about the isolation of the inner languages of visual art, for instance, exploring form *or* line *or* colour *or* texture. Hence the cul-de-sac of the blank white canvas – a perfectly logical destination for

artists focusing on form, but a dead end as visual art. You can't really have a School of Blank White Canvas painters outside a Monty Python sketch. As conceptual art, however, it is intriguing and meaningful and, under the new rubric, it is art. Although the blank white canvas was the end of the road for the visual art of painting, it was a powerful statement as conceptual work, capable of engendering serious thought. Indeed, trying to figure it out decades ago helped set me on the road to the present theoretical romp.

What about the other languages? In focusing on line instead of form, you end up with Pollock and the linear, calligraphically inspired delights of Brice Marden's *Cold Mountain* series. From its separate God to its analytical sciences, the western mind is given to fragmenting in order to understand; unaware of the irony, western artists followed the same path in emancipating their art.

The Chinese were different. Their syncretic minds, balanced between the intellectual and the trans-intellectual modes of consciousness, achieved the same underlying emancipation of the languages of art in an integrated manner, with no need to abandon any of them in order to focus attention on others. There *was* no aesthetic or intellectual tyranny; ergo, no revolution was needed. Without the urge to isolate or separate and de-emphasise form, line, colour and texture in favour of subject matter, they integrated the various languages of art, allowing form

and line (particularly) as powerful, primary, fully eman-cipated languages of the visual arts without abandoning subject matter. To do otherwise would have seemed as silly to them as deciding which leg to walk on.

What does this look like in practice? If we look at fourteenth-century Chinese paintings as primarily expressions of subject matter, they can be tediously similar – predictably monochrome mountains, trees, an isolated retreat, a strolling scholar with a walking staff. But if we focus on their inner languages, particularly form and line, they come alive, each different and wildly exciting. The languages so belatedly emancipated in the West by the artistic giants of the twentieth century leap out from the painting to stun the knowing eye.

Many indications of their aesthetic precocity arise from the Chinese approach. Their high art has been, for centuries, an intimate, personal affair. Paintings evolved from walls and screens (room dividers) to more intimate formats such as hanging scrolls, handscrolls, albums and fans – all formats that could be picked up and handled, shared with like-minded friends and then put away again, keeping the process constantly fresh and alive. The art that mattered to this sophisticated aesthetic culture was intimate and private, made on a manageable scale.

In the West, serious paintings and sculpture tended to be altogether less intimate. Increasingly throughout the centuries, they became fixed objects for general display

(even if, for the elite who displayed them on a permanent basis in their homes and palaces, to a fairly limited audience). This tended to encourage monumentality – single large framed pictures occupying a whole wall, or a statue dominating a courtyard, for example.

Compare and contrast with China, where monumental pieces such as Buddhist sculpture or Tang horses were never considered high art. They were functional pieces, designed to propitiate the gods and provide for the afterlife. Conversely, the arts of the elite were on a smaller, more private scale designed for intimate enjoyment. Two key differences between the arts of the two cultures might be stated as follows. In China less was more, whereas scale was an important indicator of importance in the West; the Chinese favoured clarity and sagacity over complexity, novelty or virtuosity, whether in painting or poetry. The legacy of the modern western revolution in the arts, because of the lack of understanding of its fundamental aim, favours surface novelty and clever ideas; virtuosity over sagacity and clarity, encouraged by a continued focus on the art object. We must shift that focus if we are going to construct a workable, universal theory of art.

5

process over product

You're confusing product with process. Most people,
when they criticise, whether they like it or hate it, they're
talking about product. That's not art, that's the result
of art. Art, to whatever degree we can get a handle
on it (I'm not sure that we really can) is a process.

Jeff Melvoin

Although today most people in the art world
recognise that art is a process, I'm not sure we
have taken the implications of this far enough
in practice. This is not just my view, but that of many other
working artists and critics too: in *Playing to the Gallery*,
Grayson Perry suggests that it remains a problem, as does
the vociferous response to Duchamp's *Fountain* being
voted the most influential work of art of the twentieth
century. Lingering prejudice continues to warp our view,
both within the art world itself and particularly outside
it. So the first essential shift in perspective that we need
to make is to expand the horizons of our illusionary
product-based approach to art theory.

We used to be able to manage with the belief that the

physical art object was the end product of art, and the process of art was everything that went into achieving it. In this view, the artist, with visionary capacity, reaches into a realm less accessible to normal perception and, through acquired technique, translates vision into a finished work of art – the art object itself. As part of that process, the artist communicates inwardly at first. The act of creation is a learning process for the artist, as both vision and techniques are honed by the production of each art object. The process is one of considering, refining, learning – in an exchange with the self. As the ever-quotable Picasso said, 'I am always doing that which I cannot do, in order that I may learn how to do it.'

Then the audience enters the mix, perhaps first in the form of a friend with access to the studio, and the communication begins to shift outwards to others. Once the art object is complete, however, and presented to a broader public, communication becomes primarily outward. The artist is done, although a work of art may be revisited at a later date – but in that case the artist might almost be considered as part of the audience too, albeit to his or her own work, adding to an original work of art as a response to it. We'll revisit that intriguing idea shortly.

I suspect we can all broadly agree with the process up to the point of the physical work of art. What's crucial – and what is crucially missing from most contemporary views of art – is how we see that object fitting into

the overall process, including the response from the audience.

Until the modern revolution in the arts, the prevailing view in the west was that the vision/artistic-technique/art-object trio *was* the process of art, with the art object seen as its end product. The role of the audience in that illusion was seen as that of separate observers, delving back through the encoded languages of visual art to grasp a little of the artist's visionary insight. Within this system, artist and audience were seen as entirely separate, the physical work of art standing between them like a fence. That in turn allowed the comfortable illusion that we could judge the physical work of art independently; that it was a separate, self-sufficient entity which was the art. The question 'Ah, but is this a work of art or isn't it?' – 'Once more unto the pissoir, dear friends, once more ...' – then seemed pertinent, even sensible.

During the modern revolution, we have seen movement after movement in the visual (and other) arts where this lingering belief in the art object as the isolated, self-sufficient end product led to mighty arguments and a great deal of consequent confusion, as the 'old' way of viewing art came face to face with the new art. 'Is this physical object a work of art or not?' became too narrow a question; one that seemed workable with the old art, because it was a product of our thought process, of our level of consciousness, which conspired to *make* that a

sensible question. The new art blew all that right out of the water. So if that is the wrong question, what is the right one? One simple shift in perspective is all that is needed to answer that and many other questions.

Here's the trick: instead of seeing the artist's side of the art object as being the process and the art object as being the end product, we include everything on the audience's side of the art object as part of the process as well. We don't have to reject the vision/technique/object trio discussed above; instead, we simply add two more elements. First, we include audience *techniques* in reacting with the art object; and secondly, we include audience *vision* in translating that into enhanced consciousness.

We will look at vision in more detail in the next chapter, but it's worth a short diversion here to talk about techniques. You may well wonder why the audience needs technique at all – 'I just look at the bloody thing, don't I?' But there is, of course, no such thing as 'just looking'. As Schrödinger and his cat knew all too well (or, possibly, didn't), the mere act of observing a phenomenon or system fundamentally changes it. And so it is with art; the audience is a part of the process whether they like it or not. But just as there is more than one way to skin a cat, there is more than one way to become part of the artistic process.

Whichever way they choose, an observer must apply some skills of their own to the experience, just as the artist

must apply their skills and experience to creating the work in the first place. In this sense audience techniques are a parallel to the artist's techniques, but on the other side of the 'fence' of the work of art; they are an active rather than passive response to the process, a response that acknowledges that just as the artist put great effort into acquiring their skills and expressing their talent, so the audience must respond in kind.

I am not suggesting for a moment that everyone needs an art degree before they are capable of understanding art. But I certainly am suggesting that some investment in time, and an openness to perceptual refinement, will be richly rewarded. Let's look at an example of how this might work in practice, based on a famously contentious artist. A Jackson Pollock may look to the uninitiated like someone splashed a few cans of paint over the garage floor; so how do we use audience techniques to move from that perception to a fuller appreciation of the work? The good news is that they don't have to be arduous to acquire.

One might first read about how Pollock's gradual abstraction led to abstract expressionism. A quick YouTube search will reveal several films of him working, which will help to understand the thoughtful process involved, and to see that although apparently unstructured to the unknowing eye, there is a great deal of composition involved: layering of contrasting colours,

balancing of thin and thick lines. By such simple means we can learn to see these processes and follow them. We can understand their inner meaning and their power to communicate; we can start to learn the language of line, to get what Pollock is 'saying'. And then we come again to the innermost languages, such as confidence. We need to be able to read the confidence in what he is doing – part of the mix of languages that reveals an apparent mess on the garage floor to be high art.

At their most advanced, audience techniques involve not only learning whatever art history is necessary to put the work in context, but everything else that this book is about: learning to see, learning to grasp that the process is the art, and how to interact with it. They also involve understanding the background theories involved, from process aesthetics to any -isms involved. Above all, they involve bringing a knowing eye and mind to every aspect of the process.

When we do this, we tear down the fence between artist and audience. Instead of being a separate observer intent upon grasping a little of what the artist means, the audience becomes a full participant in the process of art. Through audience techniques, with all the aesthetic and art-historical means which that implies, observers use the art object and everything that went into its production to enhance their own consciousness, to reach *for themselves* into the visionary realm. The audience becomes an equal

partner in the creative response to experience. The entire process thus becomes the art; the *real* end product is the evolution of personal and, thereby, collective consciousness, however one cares to define that. For me, that translates into Enlightenment – but the theory works just as well for those who prefer that with a lower-case 'e'.

This seemingly simple but crucial shift in perspective makes our approach to art infinitely more comprehensible and effective. It allows even the weirdest of our recent creative forays as art. It allows for the many variables encountered when experiencing art, including the all-important context. And it shifts the appropriate question about art from the object to the entire process – 'Has my involvement in the process, of which this particular art object is a part, raised my consciousness in any way?'

Whatever the answer to that question, the fact that we can ask it gives art new life. With the full emancipation of art, we must also allow it the freedom to be anything, to do anything and, more to the point, to *say* anything; to have free speech, if you like, but also to have freedom of expression in the languages beyond speech. Nor do we have to agree with what it is saying, only with its right to say it. We may offer an opinion as to what particular aspect of art moves us, or alters our consciousness, but while there is much to discuss, there is nothing left to argue over. No more right or wrong, no more

stomping away from a loud argument with 'If you think that rubbish is art, you're an idiot!' This simple shift in focus from product to process-based theory in the arts, and the acceptance of an equal role for the audience as part of the process, takes out not only the arguments but the angst too. It makes art astonishingly more efficient in its role in evolving consciousness and, by removing the confusion and angst, far more fun to play with.•

Where does this leave us? With the products de-emphasised in favour of the process, we can get to the point of art much more readily and with far less confusion. Instead of stumbling about wondering what the various art objects mean and whether they are, as objects, art or not, or whether the artist *is* an artist or not, we focus on the question of whether the entire process means anything significant to us as individuals. Nor need we agree with anyone else over this. There is no right or wrong in the process of the enhancement of personal consciousness. The answer for each individual looking at

• Promisingly, what takes the argument out of the pile-of-bricks conversation might also lead to a way to defuse a broader swathe of ideological confrontation. It seems to me that today the greatest danger threatening humankind, capable *in extremis* of actually bringing to an end the evolution of consciousness, is conflicting ideology. But this is probably not the place to explore that possibility, even if laying the foundations for doing so.

Carl Andre's *Equivalent VIII* (the famous 'pile of bricks') would differ, of course. But it is significant – and an indication of the need for the theory I am proposing – that even in 1976, when this work was daubed with paint at the Tate by a visiting vandal (or ironic, uninvited collaborator in the ongoing process of art – and we will revisit the implications of that intriguing possibility), this act led to famous and furious arguments over its status as a work of art, almost a century into the revolution that made such a debate utterly pointless. Freedom's like that. Everyone gets to make up their own mind, and it can get messy.

The simple shift in theory from product- to process-based aesthetics, along with its necessary redefinition of the process, clarifies a great deal. It is admittedly a broad shift, as it needs to be, but it has two essential features which make it work: it makes sense of every aspect of what went on in the West from the late nineteenth century into the late twentieth; and it can be applied equally successfully to any art, from any culture at any time.

This shift in no way negates or disparages any of the individual aspects of art, and certainly not the pivotal physical art object; all remain important *at their own level*. Nor, below the overarching role of art in evolving consciousness, is there any particular hierarchy of levels. The hierarchy is ever-shifting, and reflects individual

focus from moment to moment. What may seem very important to one person may be of peripheral interest to another in the process of raising consciousness – as in the wider field of that endeavour. We move beyond the intellectual pressure to focus on *separation*, not only of the physical work of art from every other aspect of the process, but of artist from audience, and of audience into separate functions (collector, dealer, auctioneer, academic, curator, etc.); even gender or race issues. These all tend to encourage distinctions about aspects of the process that can be diverting. There is definitely a place for such considerations, and no reason why anyone shouldn't elevate them to prominence either as artist, directly addressing the issue in a work of art, or as audience. That is the beauty of the process-based approach; it is entirely up to each individual to decide upon appropriate focus and relative importance from moment to moment. But this should not be encouraged to divert overall attention from the process as a whole or, like conflicting ideologies, to be taken more seriously than they should be from the broader perspective. At its highest levels of communication, art is blind to race, gender or any other separating factor. If we focus on process, the question will cease to arise.

It is fair to point out that a good deal of what I am saying is well known, at least in parts, to many in the art world. But, boldly stated as part of an all-encompassing

art theory, much that it reveals has not been previously considered in depth. Before we continue on our journey, let us spend some time considering how artists themselves look for previously unconsidered revelations in the world around them.

6

the vision thing

There are three classes of people: those who see, those who see when they are shown, those who do not see.

Leonardo da Vinci

Vision is the art of seeing what is invisible to others.

Jonathan Swift

We've been bandying the 'vision thing' about a bit, and we all probably have some idea of what it means. But what really is vision, and why does it matter?

First things first: the more creative people are, the more they see things differently. Creative ability, and that essential urge to express it, refine the artist's ability to see. The moment one begins to draw or paint, one is forced to look more piercingly at the world and its details. Without artistic focus, it is easy to look at a tree and see, well, a tree. It may be further identified as a particular type of tree if one is botanically curious, or be characterised by an adjective such as 'big', 'lush', 'old', 'beautiful' and so on – but that is generally as far as it goes.

The artist looks at it and sees patterns. In order to paint it, it is necessary to understand how the trunk gives way to the branches, how the bark changes as it goes from ancient trunk to new shoots and how the intensity of colour changes between the broad trunk lit from without, revealing its surface texture, and the thin twigs at the ends of branches, darker because they are silhouetted against the sky; how the branches arrange themselves in a symphony of natural lines; how the green of the leaves varies with new and old growth; and how light creates patterns of shadows in the foliage. If you laboriously paint every leaf individually, you can depict the tree. But if you grasp the *patterns*, you don't need to do that – you can delve into essence rather than surface reality, revealing an inner truth. That is vision; it reveals essence.

Once these patterns are grasped and absorbed, the artist can reach into the essence of the tree. And at that point, it becomes easy to paint it in a revelatory manner. The artist is free to let rip in all the languages of visual art. Colour can be changed, form simplified, patterns abstracted, texture emphasised, line set loose to dance wildly. The essence, the spirit of the tree resides in these patterns; the artist expresses not just the surface of the tree, but what is hidden from ordinary view.

But it goes deeper than that. Ansel Adams summed it up neatly:

You don't make a photograph just with a camera. You bring to the act of photography all the pictures you have seen, the books you have read, the music you have heard, the people you have loved.

That is all part of the visionary mix. Nor, of course, does the vision of one artist match that of another – it is a personal thing, as it should be, otherwise we would only need one artist. We all see essence differently, and that is important to the evolution of consciousness; it is the combined wisdom of creative individuals, capable of expression both within the languages of reason and beyond, that raises consciousness most effectively.

The same is true of great portraiture, of course, where we value not just a physical likeness but the capture of that inner spirit, the personality of the sitter; as, indeed, does the cartoonist at a more obvious, usually satirical level. Grasp that, and the artist can do a Bacon on anyone; they can take it so close to the edge of reality that we aren't really sure whether we are looking at a portrait of the sitter any more, or of the soul of the artist. Ultimately, one can argue, all art is a portrait of the artist.

However the artist chooses to express those perceived patterns, the painting will be evocative. We can extrapolate that to other aspects of visual arts, or to any other art form. In abstraction, for instance, the artist sees formal

patterns and harmonies, formal essence, that others would miss. In music it might be hearing the patterns, rather than 'seeing' them, but it is essentially the same idea. In performance art, or conceptual art, it is being able to 'see' what will work, what will evoke emotion, what will move an audience, what expression of essence brings a high level of meaning to the endeavour.

This capacity – part innate, part acquired – is the vision thing. And of course, it can be applied to all sort of disparate ends; not just representations of objects or scenes, but more abstract human concepts. One might be inclined to see patterns of injustice or hardship in such a way that they can be expressed through art in a way which changes our attitude towards them. Essentially, however, it is all the same capacity: to perceive and express what others cannot in such a way that they too begin to understand.

The extent of visionary input varies enormously, of course, as does the impetus for creating art. Whether an artist is striving to produce masterpieces to inspire humanity through the ages or cranking out repetitive banalities for an unknowing audience makes no difference to the process, only to the depth of understanding and impact involved.

That, essentially, is artistic vision. And of course, it is not in any way confined to the artist on just one side of the art object. As discussed in the previous chapter, audience vision in grasping meaning, often in ways not

even consciously intended by the artist, is an equally vital part of the process of art. People without their own ability to see essence may initially be in awe of the artist's capacity to do so and to express it so powerfully, but by becoming involved in the process they inevitably begin to acquire some of that visionary sensibility for themselves. Through art they can begin to see as artists see; and the more they understand the process and approach it creatively themselves, the further they advance their consciousness.

Those who are comfortable as passengers through their own lives can get away with just noticing the scenery. But if you wish to be creative, to change things, to have an impact that transcends your individual timespan, you have to pay attention. You need a curious mind; you need to learn to look beyond the surface and truly see and understand the esoteric truths that lie beneath it.

Vision, then, is another tool for breaking down the barrier between the artist and the audience, another weapon in our process-based aesthetics arsenal. Process-based aesthetics questions distinction; it doesn't deny that distinctions exist or are useful, but it de-emphasises them. In breaking them down, it moves us further down the path towards our ultimate goal: the evaporation of the distinction between artist and audience altogether. The most advanced aesthetic cultures reflect this in a variety of ways, but particularly with the formats, materials and range of art; all of which we explore later.

7

facets of art

Great things are not done by impulse, but by a
series of small things brought together.

Vincent van Gogh

It is misleading to define art by the physical work of
art in isolation. The physical art object is, however, a
convenient place at which to start determining what
art really is.

There are essentially three separate aspects of a
painting or other work of art: the medium, the message
and the marketplace. The medium is the physical object
itself; the message is the meaning (in its myriad possible
forms) embodied in the physical entity; and the market-
place is where medium and message are dealt with there-
after, both commercially and academically.

Each of these is dendritic or tree-like; as trunk gives
way to branches and then multiple twigs of interpreta-
tion, they become less and less visible, less susceptible to
interpretation and intellectual grasp. But as we shall see,
it is ultimately the role of art to befuddle the intellect, so

this is just part of the way in which it plays its essential role – something which we will expand upon later.

The physical work of art is the simplest to deal with. It is made up of certain material components collectively known as the medium, which can usually be identified and understood as precisely as a painting can be measured. With the fruits of science increasingly at our disposal, we can now figure out a great deal more about its makeup than ever before, right down to the source and age of some of the components and even beyond them – whether there is another image beneath the surface painting, for instance.

The message is more complex. The most obvious aspect of this comes from whatever the artist knowingly included – any representational subject matter together with its overt symbolism, for example. There are more subtle levels of meaning intentionally or reflexively expressed in the less obvious languages of visual art – those inner, gestural, visceral languages touched upon in chapter 3. These are perceived as much emotionally as intellectually, discernible to the initiate although often undefinable. There is also subliminal, inbred cultural meaning that the artist may be completely unaware of. And beyond *that,* we also deal with meaning which emerges only from extended audience input. Art historians today may read far more from a Renaissance painting than could its original target audience – for instance, its

historical context, which by definition can only be clearly understood in retrospect.

It is worth returning here to the need for explanation expressed by Boris Johnson, reflecting the old paradigm of visual art. One can begin to explain a religious picture, a battle scene, a train crossing a bridge, a port scene or a haystack for its imagery, intention and symbolism. But once art is autonomous, its inner languages emancipated and process-based aesthetics dominant, great swathes of art 'meaning' are less susceptible to explanation. Even if the artist could explain everything she may have intended and was able to put into her painting, that would be only a fraction of its meaning. There always remains a range of aesthetic communication beyond precise explanation. In process-based aesthetics this would include, quite apart from the unconscious, socio-cultural input of the artist, the entire range of possible interpretations of the audience, with its infinite variety of 'meaning' stretching ever into the future. Boris wanted the 'Saatchi mob' to clarify what they were up to in their artistic attempts to expand consciousness; I suspect the 'Saatchi mob' would be just as grateful if Boris would get off *his* arts and try to see the broader picture of which they are an integral, influential and effective part.

As an example of meaning emerging through audience participation, it occurred to me while writing this book that the blank white canvas is an excellent illustration

of the Enlightenment experience. If one were to illustrate the experience here, it would be as a blank white page, which would provide an excellent example of the importance of the audience in art, not only in interpreting the blank page but in reinterpreting its meaning. It doesn't seem to have occurred to anyone to explain the blank white canvas as the closest one could get to *depicting* the subject matter of Enlightenment, which, in turn is the end product of the process of art. But if the process of art is a powerful vehicle in our journey towards Enlightenment, then perhaps a work that straddles the border between painting and conceptual art so perfectly might, unconsciously, have hinted at that state without anyone noticing for the best part of a century. To what extent that might be true is neither here nor there; it is a powerful indication of how art objects, once they exist, carry meaning and messages which only the audience can distil in the alembic of time.

The individual meaning imparted by the audience is an important aspect of the process. Everyone will approach the physical work of art with a different mix of socio-cultural input, emotional baggage and personal prejudice: '*The Starry Night*? – makes me dizzy, darling, with all those swirly bits. I don't care *who* painted it!'

That work by Van Gogh, which we value highly, takes us neatly on to the subject of the marketplace, where art is a commodity – both commercial and intellectual.

Where students, academics, art historians and curators regard the message, context and subtext of the physical work of art as their currency, dealers, auctioneers and collectors also treat the physical object as their coin. Any participant may delve into any aspect of the meaning of an art object, for a variety of reasons and involving a variety of intellectual currencies. It's rarely possible to predict which facets apply to which participant; a dealer may be more interested in the academic side of a particular painting, in the same way that an academic may apply his skills in studying it in order to gain fame or money.

One key aspect of the marketplace is that every accretion to the work of art also affects its importance and its commercial and emotional value – and, therefore, its impact in the art world. This is true regardless of whether that accretion arrives from the artist's side of the art object or the audience's. Ronnie Wood or Tony Bennett may both be perfectly good painters, but their fame as musicians inevitably enhances the profile and appeal of their paintings. Provenance also enhances the appeal of an art object. A painting that once belonged to John F. Kennedy, or Napoleon, or Elizabeth Taylor, is going to have a greatly enhanced profile in terms of its meaning to the audience and, therefore, its commercial value. (The same is true of anything else once owned by celebrities, of course. JFK's golf-clubs are worth more

than my brother's – about $1.16 million more, in fact, the amount they sold for at auction in 1996.)

To make the point about asking particular questions not of a physical work of art, as we have done in the past, but of a particular aspect of the process, one very simple example will suffice. Let us pretend that Elizabeth Taylor owned a lousy painting and it sold at auction for far more than it would have done had my brother owned it. If we ask of the art object, 'Why is such a poor painting making ten times its apparent value?' there is no sensible answer. But if we ask why the Liz Taylor provenance makes it worth ten times as much, the answer is that we value her association with the painting. Once we know we are dealing only with an increase in value based on the oomph factor of famous provenance, we get a straightforward and sensible answer. This may be blindingly obvious, but serves to illuminate the importance of asking appropriate questions of particular aspects of art. And you will, of course, get different answers from different aspects of the process, some even contradictory.

Further aspects of the process exist in the manifold roles of art – from the banal (matching the curtains) to the indefinable (the metaphysical, transverbal or otherwise spiritual content). The multifaceted aspects of art are, to some extent, interdependent. For instance, every additional layer of meaning that is revealed in a work of art will inevitably affect both its commercial and

academic value. The same is true of its history of publication and exhibition, and its history of ownership or provenance; particularly if it has passed through the hands of a famous academic in the field, a knowledgeable collector or a celebrity.

Other events also have an impact upon the profile and, therefore, desirability of a work of art. If the *Mona Lisa* had not been stolen from the Louvre in 1911 by Vincenzo Peruggia, it would probably not today be the single most famous painting in the world. Absent for two years, it gained worldwide fame to the point where in its absence thousands more people visited the Louvre to gaze at the empty space where it had once hung than ever used to visit it when it was hanging there.

Vincenzo's caper added immeasurably to Leonardo's intriguing and accomplished but otherwise relatively straightforward Renaissance portrait, vastly enhancing its value in the marketplace. Today on the open market it would probably become the most valuable work of art ever sold, potentially worth billions of dollars as the ultimate art trophy and the slickest of social grease: 'Do come and visit, Mr President. We'll put you in the Mona Lisa Suite.' The auctioneer involved would, no doubt, stretch to buying a nice little bunch of flowers to put on Vincenzo's grave. It may not be many years, however, before a Chinese masterpiece from antiquity will become the world's most valuable work of art, although it too

may also be in a museum and so only theoretically 'on the market'.

It is the nature of the multifaceted process of art that encourages the wealthy to think it worthwhile to spend tens of millions of dollars for a Van Gogh or a Warhol. It is not just the physical work of art that is valued so highly. This can be readily demonstrated as follows. Imagine hanging the top ten most expensive paintings in the world alongside 100 carefully selected and well-painted works of similar types but by unknown or less well-known artists. Throw in a Van Meegeren forgery of a Vermeer if you are feeling mischievous, or a Wolfgang Beltracchi fake of a Fernand Léger. Then erase the memories of the world's wealthiest collectors so that they had no information whatsoever about the works or the artists, or their esteem in the art world, their history of publication and exhibition, their provenance or sales history. Then ask them to select the paintings they would be willing to pay $50 million dollars for. I don't think they would be queuing to write a cheque.

The fact is that it is not the paintings alone that these collectors are paying for. Whatever artistic vision and skill they may or may not perceive in the art object, they are paying such astonishing amounts of money precisely because of art-world context. What adds immeasurably to the art object itself is all the background of artistic fame and historical setting provided by biography, art

history, publications, exhibitions, major museum and private collections, provenance, the sales record of both the individual work under consideration and other works by the artist, and indeed by other artists, to establish a 'league' in which such prices are standard and acceptable. They are paying for social acceptance, a boost to self-worth and a host of other more subtle considerations. And they are also paying, in some cases, for the effect that a notorious theft and restitution has on public awareness of a painting and its value, as in the case of the *Mona Lisa*.

Monetary worth, then, is only one facet governing the place a work of art occupies in the overall hierarchy. If we ask the right questions, knowing to which aspect of art we are addressing them, we can arrive at a sensible assessment of the overall place in the hierarchy of arts of any particular work, and a sensible assessment of how much time to grant it to allow it to work its magic on us. The status of a work of art, that consensus of respect, is a guide to the level of attention we might give it in order to see if it works for us as it has worked for so many others. That is why if you stand in a museum or gallery you see a disproportionate number of people paying more attention to the labels than to the art.

I have watched people deal with exhibitions of paintings by going from label to label, reading them with care before barely glancing at the works of art. The label

is a clue as to how important the work of art is. See 'Joe Picklenick (b. 1986), *Splodge of Blue*' and you are unlikely to give it much time or attention. But when you come to 'Vincent van Gogh (1853–90), *The Starry Night*', you are going to give it time, pay attention and probably stand in awe in front of one of the world's more famous paintings (although you may be initially a bit disappointed in the scale, as it's surprisingly small). But even the worldwide fame of this particular painting rests in part upon a later accretion: the Don McLean song 'Vincent', which added significantly to the commercial value of the painting and brought it to the attention of millions of people who might otherwise not have heard of it.

There is a hierarchy in the art world which governs what we approach with respect and awe and what we skim over. But like everything else in the past century or so in the West, this has been radically adjusted because of the equally radical shift in the arts themselves. We used to entertain the comfortable illusion (again because it was reasonably workable if not examined too closely, and because it fitted our world-view at the time) that 'fine art' could be identified by the purity of the discipline from which it came; so music, painting, sculpture, architecture, poetry, etc. would usually figure in a constantly shifting list of 'fine arts', although some definitions tended to confine it to the visual arts. That term, although still current in the art market, is rarely used in

academe any more, as our modern western artistic revolution has revealed the illusion for what it is.

We also happily distinguished between fine art and applied arts; the former as something created mainly for its aesthetic or intellectual content, the latter having more to do with the production of functional objects (crafts). But, again, such terms no longer make much sense. Consider Keith Gessen's comment in a 2014 *Vanity Fair* article: 'But art by definition is something for which there is no practical use.' No practical use?! It matches the curtains, it acts as social grease, it is an efficient means of storing information from one generation to the next, it is a wealth-storage system, it informs and educates, it is spiritually uplifting, it raises consciousness. What does he want – snow-tyres on a Giacometti? But it is worth examining hierarchy in the arts, even if we need to rethink the details and deal with the overall process rather than the product or the discipline from which it came.

It is clearly pointless today to declare that if it's a painting, then it is fine art; if it is a chair, it's craft. Go and look at the railings on the north side of Hyde Park on a Sunday morning and you'll find plenty of paintings you wouldn't want to even sit on, while furniture comes up at major auction houses that is undeniably art. You'd happily have a chair by George Nakashima (1905–90) in your home as much to admire as to sit upon; in fact, at auction it would have a sign on it saying 'Please do not

sit on this chair', a piece of subtle salesmanship the irony of which one hopes would not be lost on whoever put it there.

The point is that with a shift from object-based aesthetics to process-based aesthetics, the justification for such a hierarchy based on disciplines evaporated. It only ever worked in any case because we convinced ourselves that it was viable – another illusion. But it was also, to some extent, self-perpetuating as a myth. State that painting is a high art, furniture making a craft, and you instil in a culture an inborn preference in its creative individuals to reach for a brush and canvas rather than a saw and a plank of wood. Consequently, the creative elements in the culture tended to be channelled into what were considered the fine arts, the circularity of the process bolstering the spurious definition. If we focus on the process rather than the products as defining art, then distinctions between the various art forms become irrelevant. High art, low art, and all the levels of art in between become far more flexible terms, with individuals allowed the freedom to decide for themselves. Consensus then eventually coalesces into some sort of meaningful definition. But consensus, by definition, takes time; one reason why buying contemporary art straight off the easels of the potentially up-and-coming is such a minefield for investors. Exciting, yes, but dangerous as a financial punt. Buy enough, of course, and the risk factor is smudged

out across many works, some of which will come spec-tacularly good even if the majority end up in the attic. After a while, when the aesthetic movers and shakers and their countless followers all decide that *The Starry Night* shines, while Joe Picklenick's *Splodge of Blue* is no more than, well, a splodge of blue, then a viable hierarchy coalesces; poor old Joe slips into obscurity while half the world gets to learn that Vincent was, apart from being a terrific painter, one ear short of a set at the end of his life.

So what matters nowadays is the level of understanding and insight expressed by the entire process of art, on both the artist's and the audience's side of the art object. The medium through which it is expressed, the art object itself, becomes no more than an incidental part of that process. In market terms, in terms of matching the drapes or brightening up a room, it is still a vital part, pivotal; but it is no more than a vehicle for art's loftier ambitions. Art has always been what artists did, although through the old method of judging it, we may have excluded a bunch of real artists because they were doing the 'wrong' thing. Today, however, art is what artists *and* audiences do; high art is what the most effective artists and audiences do. Tap-dancing on an upturned bucket on the corner of Threadneedle Street has the same *potential* for high art as a painting or a symphony. Ultimately what we require of both artist and audience is to accelerate the evolution of our personal and collective consciousness. This may

be more difficult to express on an upturned bucket, but we can't rule it out; I suspect that Sammy Davis Jr. could have managed it without breaking a sweat.

None of this implies that we should abandon low art, or any art. If only the most profound art existed, only a tiny proportion of humankind would be touched by it, and art would struggle in its highest role. Sagacity is relative, analogous to a ladder to be climbed, with many rungs at different levels suited to any sensibility. No rung is more important than another; least of all the top step, which is meaningless without all those below. In the visual arts, an intriguing surface innovation may capture the attention of the neophyte more effectively than the brushwork on a Chinese handscroll, but the basic requirement is the same: art should intrigue long enough to begin the process of enlightening. It should inspire those involved at all levels on both sides of the work of art to evolve individual and, thereby, collective consciousness, to move ever upwards from the obvious to the esoteric, from the banal to the lofty. That is how art works: first it captures the attention at whatever level the artist and audience are open to, and then it lifts it higher.

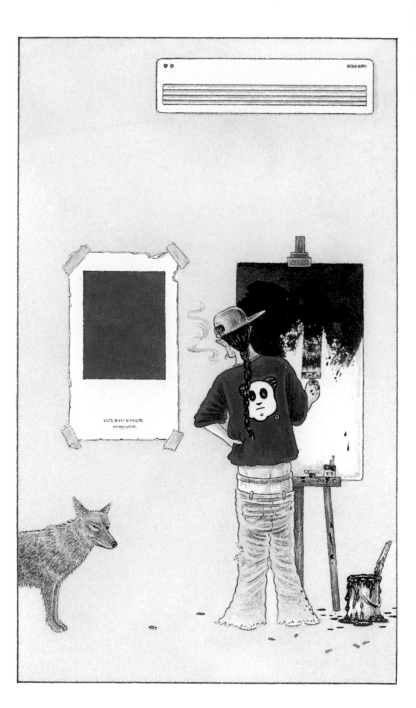

8

the modern revolution

The history of modern art is also the history of the
progressive loss of art's audience. Art has increasingly become
the concern of the artist and the bafflement of the public.

Paul Gauguin

I am quite certain in my heart of hearts that modern
music and modern art is not a conspiracy, but is a
form of truth and integrity for those who practise
it honestly, decently and with all their being.

Michael Tippett

In the art world, the term 'modern' carries a lot of
baggage. It is not just an aesthetic term but also a
cultural one, and a complex and confused one at
that. More problematic, though, is that modernism as we
typically understand it is subtly ethnocentric. It tends to
judge the 'modern' art of all other cultures against the
benchmark of the recent western revolution in the arts,
setting that up as the pinnacle, the cutting edge of global
art; thus fixing 'modernism' in both time and place,
and adopting an inherent belief in western aesthetic

precociousness and superiority. For all its vitality and excitement – it was, after all, a revolution – its main achievement was to finally (and, let it be said, belatedly) emancipate art for *western* culture, so that art could finally take its rightful place in the driving seat of the evolution of consciousness there.

The Chinese, as noted in chapter 4, achieved this centuries ago without the need for artistic revolution, since there was no fundamental aesthetic tyranny to overthrow (although as we know, plenty of everyday tyranny permeated the thousands of years of feudal and then imperial culture). Their version of our revolution was nothing more than a gentle evolution, and it took place so long ago that it makes nonsense of the term 'modern' as anything other than a chronological definition (which it has long since transcended, adding to the confusion). The Chinese simply evolved their arts to full maturity, with the emancipation of all the languages of art, centuries before the West.

This may not go down well in some parts of the world, but the fact is that there were only two reasons why the West got away with its global co-opting of cutting-edge art. The first is that its modern revolution threw up some genuinely exciting works, the surface appearances of which were quite unlike anything that had gone before. It was being fought by a culture steeped in the scientific approach of the rational, reasoning state of consciousness,

so our artists ironically proceeded to revolt intellectually against intellectual tyranny. The natural inclination of artists in an intellectually dominated culture was to fight for freedom by lining everything up on the laboratory bench and examining it separately, just like scientists – analysing, separating, dealing with the languages of art one by one until they had exhausted the options (back to our blank white canvas). This granted an entirely new and incredibly exciting range of possibilities to the surface of art, so the results looked fundamentally new and different, but the underlying achievement was *not* fundamentally new.

The shift in theoretical perspective to process-based aesthetics, de-emphasising the object in favour of the process, reveals that the Chinese reached the same point centuries earlier. They have been painting wildly abstract and abstract expressive paintings since the fourteenth century CE if not earlier, but they just never felt the need to do so in separate paintings; they were able to combine emancipated form, line, colour and texture with figurative subject matter. That is why the subject became less important, to the point where it was acceptable to settle mainly on landscape and paint similar scenes over and over – it was no longer about the scene. Subject matter was just the welcome mat at the doors to perception and expression. The subjects were form, line, colour (in the Chinese ink-painting tradition the endless tones of ink

and water are considered colour) and texture and, underlying all of these, again, the languages of confidence and sagacity.

So the Chinese arrived at a very 'modern' fusion of arts long ago. The highly educated literati combined painting, calligraphy and poetry in what became known as the 'Three Perfections' by the fourteenth century. This was a natural outcome of fully emancipated pictorial art. While the western mind tended to be selective, the Chinese mind tended towards syncretism as a result of the influence of Daoism and the Chinese take on Buddhism. To the western mind, something was either abstract or not; the Chinese mind saw no reason why it shouldn't be both at the same time, nor any reason not to combine three art forms beloved of the aesthetically influential minority. It is not until the twentieth century that we begin to see the incorporation of text (other than as calligraphy, title or signature) in western art.

The second reason why the West was able to annex the idea of modern art was that while the modern western artistic revolution was being fought, its technological might brought it close to global hegemony. The Victorian dominance of much of the known world gave way to the American century as all this was happening, and the predominance of intellectual focus in the West had armed it with astonishing advances in weaponry, transportation and communication, allowing

it to pretty much dominate the world. The West was the giant with the smile and the big stick, so if it was doing something with its arts that looked quite different from anything seen before, then that too had better be taken as seriously as the big stick. Even in China, ironically, there was a century of aesthetic self-flagellation as wave after wave of art teachers and institutions belittled their own, highly sophisticated tradition of ink painting, and reached instead for western ideas and media – in China in the first half of the twentieth century, you could barely teach art without a beret and a bow tie. The usual claim among the Chinese – that it was to overthrow a stifling artistic orthodoxy – was not even entirely sensible, since a number of artists were always doing just that, and continued to do so even while the artistic upheaval in the West was taking place.

This led to a great deal of confusion and has badly skewed perception of the so-called Chinese 'modern revolution' of the past few decades, not least since Deng Xiaoping dismantled the main plank of equality within communism and began to encourage accumulation of individual wealth instead.

Between 1949 and Deng's abrupt about-face in 1980, a whole generation of Chinese artists was technically trained to extraordinarily high standards in the drawing skills that had once characterised artistic training in the West. (Coincidentally, western art schools tended, at

the same time, to *de*-emphasise such training. While a generation of Chinese artists was taught to draw like Ingres or Dürer, western art schools were emphasising self-expression over skill.) In China under Mao Zedong, art was seen as a servant of the proletarian revolution; its primary goal was to 'serve the people'. During his three decades in power, Mao took a highly sophisticated, fully emancipated visual art form and attempted to emasculate it. He denied its loftiest role, which it had been fulfilling splendidly for centuries, and reduced it to being a servant of specific ideology. He might as well have tried to pour Lake Tai into a tea cup, but the force of his personality and the power he had assumed by then almost made his attempts to suppress art in favour of politics seem possible; in fact, all it really did was refocus the talents of a generation of artists.

There were still some political constraints post-Deng, but as long as overt political criticism or unacceptable subject matter was avoided, artists were allowed to paint how they liked and, to some extent, *what* they liked. That led members of this group of highly trained Chinese artists to attempt their own 'modern revolution', mostly in western formats and media. Some very exciting art may have resulted from this, but it wasn't modern in any global sense, as its roots lay a century earlier in Europe or America; and it wasn't revolutionary in any fundamental sense, because no revolution was necessary. At best, what

happened in China with this group of artists was merely a return to relative artistic freedom after an anomalous brief (very brief in the span of art history) period of limited aesthetic tyranny imposed for political ends.

All of this activity forces us to face the elephant in the showroom of this now decades-old movement. Is this particular genre even Chinese art; or is it modern western art produced by ethnic Chinese artists, introducing a little local sensibility, a high level of skill, and some ironic takes on their modern culture into a borrowed tradition? Let's make the *Turandot* analogy: if we were to cast Puccini's opera with its Chinese subject matter entirely with Chinese singers trained in western opera, and if we then staged the result in Beijing, would it be transformed into Chinese opera? Clearly not. Chinese artists, trained in western academic drawing and techniques and using western media, do not necessarily produce Chinese painting, even if the surface subject matter is Chinese and they work in a studio in Beijing.

This recent trend in Chinese artistic output (as opposed to those artists who continue to enrich the mainstream tradition either from without or within) may have led to some intriguing art, but is barely revolutionary. Among the inevitable welter of opportunism and shallowness (which differs not a jot from its western counterpart), serious artists are involved. Regardless of their intent, some of their work is independently exciting

on a global scale, and a good deal more carries local, cultural and historical significance. Eventually much of what is happening in China will be absorbed into a global tradition of art drawn from the collective fruits of East and West, but it is by no means clear to what extent, or at what pace, that might take place – or where to draw separating lines today.

What has blown this entire endeavour out of all proportion is misunderstanding in the marketplace. Not only did China's artists take their work too seriously by believing that their revolution achieved something of much greater significance than it actually did, but the marketplace did as well. If the artists got a little too big for their boots, no harm was done. Any boost to confidence among artists can only fuel inspiration; the more they believe they are involved in greatness, the more inspired they are likely to become. Market movers and shakers blew the whole thing out of proportion, feeding the fire to the point where the entire art world, including the artists, became illuminated by the blaze – and may yet get burned.

At the heart of this confusion was the fallacy that because modern western art enjoyed such a startling revolution during the last century, throwing off vast numbers of important works that became such dizzying money-spinners, modern Chinese artists could do the same nearly a century later. Even if we question the status of the

movement as a whole, the money-spinning element may yet prove true simply because of the integrity of many of the artists involved and the massive amount of new wealth being created in China. The power of the market-place when fuelled by such wealth can be immense. The audience, however well informed, is a powerful force in determining the longevity of respect for an artist or an entire genre of art. The amount of money being thrown at this field – along with a fair amount of commercial hot air – might keep the balloon of confidence aloft. But whatever shake-up is due, the genre as a whole continues to totter on a theoretical fallacy: that the westernised art of China in the last three decades is even a little bit as authentically revolutionary as western art from Europe and America in the twentieth century.

There are only two authentic revolutions in art. The first is when art is invented as a subtle means of communication – we see hints of that as far back as the cave paintings at Lascaux, although the shift towards art that was in some sense 'good' as well as useful clearly happened over a long period of time. The second is when it attains full autonomy as a vehicle in the evolution of consciousness, free of intellectual tyranny. (This is not necessary in a culture that did not deprive it of that status in the first place – art simply evolves to full aesthetic maturity and does so far sooner than in a culture that encourages the Intellectual Tyrant.)

Despite the confusion of the past century or so, other ideas within the Chinese art community have continued to hold sway, and artists continue to recognise the long-standing maturity of their own, already emancipated tradition. Quietly, these artists have continued to explore the depth and viability of their own, primarily *shuimo* (water and ink), tradition, indifferent to the turmoil surrounding them. Some continue the tradition by renewing individual creativity within the mainstream. Others enrich that tradition through global inspiration – an endeavour that has been ongoing since the seventeenth century, and was much accelerated in the twentieth century – but they have not abandoned it to grasp for what is, to them, the somewhat illusory golden ring of the West. Today this group of artists is beginning to emerge from the shadows, and gaining due recognition as the market becomes more sophisticated. That is why there is a sudden resurgence of interest in the ink-painting tradition among knowing collectors, and why their emergence from relative market obscurity to global visibility and significance in recent decades will continue to accelerate.

9

post-revolutionary banality

Modern art is a disaster area. Never in the field of human history has so much been used by so many to say so little.

Banksy

Revolution is a temporary process; 'perpetual revolution' is an oxymoron. Revolution is *against* something, and once it is successful, its purpose is served. In both political and aesthetic terms, one order is overthrown to be replaced by another, then one moves on to hopefully harmonious existence within the new order. In other words, one shifts from conquering new realms to actually living in them, peacefully and productively.

Such cycles are an inevitable part of the modern political process, but in the aesthetic realm there should be no need to revolt again every few centuries. Once the revolution achieves its aims, the main ongoing task becomes one of dwelling in the newly conquered realms of perception and expression – a totally different process from that of revolution. There are secondary concerns, such as avoiding the drift back towards orthodoxy; but

these are inevitable in any culture, and surmountable without any further major upheaval. All that it takes for artists to participate in and contribute to the newly conquered realms is personal creativity; there is no need to keep reinventing the wheel.

The western artistic revolution was just about over by the second half of the twentieth century. The constant discovery of the new had pretty much run its course, and it was time for revolution to give way to revelation through personal creativity within the newly expanded modes of artistic endeavour. This is where the jibes at an artist like Damien Hirst by Boris Johnson and Mary Moore miss the point. Like many of Johnson's so-called 'Saatchi mob', Hirst is clearly extremely creative, and his choice of the parameters for his creativity should be entirely his. The western revolution expanded the possibilities for art; it didn't *cancel* any of them, in anything other than the most temporary, low-level way. Whether he put a shark in a 'frame' (somewhat essential given the formaldehyde) or chose to produce entirely realistic sculpture; whether he works alone, struggling in a garret, or successfully manages a massive, commercial workshop; these are all unimportant details that have nothing to do with his creativity. Make whatever judgements you like about these minor details, but the fact remains that he has helped redefine art in the West in recent decades, captured the world's imagination and advanced the

debate about art and the human condition. It is true that I have yet to see a work by him that I would want to live with on a long-term basis, but that is an irrelevant distinction that I would extend to the output of many of his peers. That would never stop me from following his activities and admiring his creativity.

The low-level battles between movements during the revolution have been wildly misleading, obscuring its underlying purpose and wasting a great deal of time and energy on background noise. Another good example of this confusion is to be found in the three famous theorists of the modern movement in twentieth-century New York: Clement Greenberg, Harold Rosenberg and Leo Steinberg, three mountains who, in retrospect, turned out to be little more than a single art-historical molehill. They helped to explain to the then-tiny art world what was going on and how to understand the new paintings – a process covered brilliantly by Tom Wolfe in *The Painted Word.* They focused on three main '-isms': the recognition of the essential flatness of the picture plane once freed of any illusionistic role; expressionistic brushwork in abstract expressionism; and the ironic re-adoption of readable subject-matter in pop art.

In explaining these movements Messrs 'berg gave the impression that each was a revolution in itself, thus obscuring their underlying unity of purpose in overthrowing the intellectual tyranny we've discussed in

earlier chapters. Once the illusion of reproducing three-dimensional life on a two-dimensional plane was grasped, the essential flatness of the picture plane became obvious; its exploitation a natural avenue to be explored by artists seeking out the 'new'. While one group was measuring the flat surface with a micrometer, another was exploring the potential for expressionistic brushwork; and the 'bergs were explaining it all, often battling with each other over who was 'right'.

There is another of the many ironies of the revolution at work here. The Intellectual Tyrant does not give up easily. Deprived of an overall mandate in the art world, he sent out intellectual foot-soldiers in the form of three highly intelligent critics to reclaim art for itself by explaining it, intellectually, to the masses (or at least, to the small mass that made up the art world at that time). But instead of seeing the phenomena they had explored as expressions of the same movement, they spent their time arguing over who was right about what. While the art itself suggested it could easily be all three at once, the Tyrant was commanding 'Choose!'

Time and time again in our quest to understand the new visual art of the West we have made this same mistake, confusing aspects of the revolution for the revolution itself – tactics for strategy. In any endeavour, including revolution, the hierarchical progression is straightforward enough:

1. Aim or purpose

2. Means of achieving aim or purpose

3. Result

In the process of attempting to cast aside the shackles of intellectual tyranny in the West, all the '-isms' – all the different avenues of exploration (cubism, abstraction, abstract expressionism, pop art, minimalism, etc.) – are the *means* of achieving the desired result, not the underlying revolution. This confusion was very considerably augmented, of course, because no one had actually stated the purpose or clearly understood it. It was not the sort of revolution where a bloke with a big beard and a lot of charisma stands up and tells everyone what the problem is, what the solution is and how to achieve it. The artistic revolution was, rather, a broad cultural imperative, coalescing through the activities of many individuals acting intuitively. The means of overthrowing the Tyrant were cobbled together as the revolution progressed, with no figurehead to state the aim and means of achieving it.

Nor did it involve only the artists. Instead of imposing rules on what could be painted and how, old-school intellectuals got straight back into the game by interpreting what was going on for the bewildered. As Tom Wolfe concluded, you couldn't *see* the art any more without the explanation. He also pointed out that while

all this was going on, the 'art world' was tiny, consisting of a small group of localised artists, a few rich patrons, some curators, and a group of critics whose main role was to explain to everyone else what the hell was going on.

While true of visual arts, this is, by extrapolation, equally true of any art. Although music, literature, architecture and other art forms followed the path towards greater autonomy at an uneven pace (with music, as ever, in the vanguard because it is the least encumbered of all the arts by its means of expression and, therefore, the least susceptible to intellectual tyranny), we can see the results of a similar urge for autonomy across the arts generally in recent centuries. This may have been more noticeable on the surface with visual art because the process of radical rejection of the old could be clearly seen, even if unclearly understood. But it is no less true in literature, where established modes of acceptable expression were radically questioned by everyone from Joyce to Kerouac and beyond; authors whose work might earlier have been perforated and hung in the outhouse, rather than held up as paragons of the new literary movement.

The same was true of expressionistic brushwork. It was simply a means of achieving the revolution, arising out of the radical changes unleashed by it. As Wolfe pointed out, the weird thing was that although abstract

expressionism had caught the attention of the press and a couple of big museums and patrons, its fame was mainly verbal – the public weren't actually buying the stuff at the time. We get the impression that Pollock was flogging paintings hand over fist, hot from his paint-streaked floor, but he wasn't. He was struggling to sell his works even as he was being deified by the art world. The fact is that most people actually still *liked* subject matter in their art, hence the next '-ism' to take the art world by storm: pop art.

People actually bought pop art. Subject matter was acceptable again, as long as it was ironic, drawn from authentic sources (such as a supermarket shelf or a comic book) and flipped the required finger at the old order; which by then, in our misunderstanding of the ever-shifting turmoil of revolution, already included abstraction and abstract expressionism. Confusion reigned; the revolutionaries were fighting against each other's isms and, like the 'bergs, never paused to ponder their underlying unity of cause. Bogged down in arguments and theories, we lost sight of the underlying revolution and focused on the noise from the barricades, which had themselves long since become unnecessary. I think we've pretty much been doing that ever since.

The West has something valuable to learn from the tradition of Chinese painting, even if many Chinese artists themselves may have lost sight of the same lesson.

In the West, without a sensible overarching theory of what the revolution was fundamentally about, and lost in intellectualising the revolutionary noise, many artists did not recognise the point when the revolution was essentially over; they kept on seeking something new on the surface of art. The authentically revolutionary artists of the past century or so were fortunate enough to be in the right place at the right time, and found themselves in an incredible candy-store of possibilities. We can only speculate on what Picasso's contribution might have been to seventeenth-century art, but we can be certain that the extraordinary advances he made, decade after decade, were enabled by his time and place. But those discoveries, the startling newness we found as we opened jar after jar of exciting new artistic candies, were a one-off, unrepeatable, time-and-place-specific phenomenon.

The continued quest for the new long after it is no longer necessary continues to dog both western and world art. Revolutionaries waving their swords and shouting for change atop rusting barricades have become an embarrassment. Art students diverted by a search for some fundamentally new art form, terrified of being perceived as working within established modes, head off in their droves down an inevitable path towards banality. The way forward suggested by the centuries-old Chinese tradition rests on exploring personal creativity within

existing, infinitely flexible, now-emancipated modes of expression. Today's artists would be better served ignoring the mirage of the new, and instead exploring depths of perception and expression within the vastly expanded range of arts made possible by their revolutionary forebears; exploring and mastering those inner languages of art where wisdom is truly expressed. There will always be a place for innovation in art, but that does not necessarily require constantly changing the surfaces of art to cater for the fleeting attention span of our modern world. Twitter art, anyone?

This may sound absurd. But I was struck by a remark by Anthony Meier, an exhibiting dealer at the 2014 Art Basel fair in Miami. Quoted in a *New York Times* article, he noted the absence of depth at the show: 'You don't see people bringing some incredible, erudite body of work that requires a meditative, quiet time looking at it. You have 2.3 seconds with everybody, and you had better grab people.' Scary, eh? Such a Contemporary Lite attitude, while entirely practical in the harsh world of art fair marketing, runs contrary to the highest ambitions of art. Our shortening attention spans, the result of our modern means of communication, are now widely manifest in our global culture, so we must expect them to be reflected in the arts; but it is nonetheless a contradiction that exhibitors at contemporary art fairs might like to consider. Their activities will inevitably encourage art collecting

among those with short attention spans, looking for that 2.3-second surface appeal.•

This can do no harm, of course. Anything that gets people involved at all is good news, and once drawn in, they can become more deeply involved. More to the point, they might become more deeply involved in *your* gallery – but there may be an opening for a different sort of art fair as we begin to understand what our modern revolution really means, and how to make better use of our arts. There must be room for an alternative to Contemporary Lite.

• As an aside, I tried an interesting experiment when I was organising one-artist exhibitions at the Hong Kong Arts Centre in the 1980s and 1990s. I commissioned an hour-long piece of meditative music for an exhibition of C. C. Wang, the same artist who started me painting so long ago. I would then time people around the show – thirty or forty paintings covering two floors of exhibition space – both with and without the music playing. Without the music, the average time spent at the exhibition was about 20 minutes; with the music it dramatically increased to about an hour. Clearly the music was a powerful aid to becoming more involved with the art. Maybe I should have commissioned some brisk marching music for Friday nights, when I wanted to get home early.

10

the writing on the wall

The whole culture is telling you to hurry, while the art
tells you to take your time. Always listen to the art.

Junot Diaz

The truth will set you free. But first, it will piss you off.

Gloria Steinem

Although we have entered a brave new world of
aesthetics in the West, we have yet to fully explore
its possibilities. China, on the other hand,
while having largely lost sight of its aesthetic maturity
during the past century of confusion, still has a lot to
offer in clarifying the nature of art and pointing the way
forwards for the West – not only in terms of looking at
its past art, but in the vital and creative re-emergence of
its core tradition.

China was aesthetically precocious because of its
belief in the supremacy of the transcendental state of
consciousness, which encourages emancipation of art; a
contrast with the West, where governance of the intellec-
tual realm has encouraged a focus on technology. The arts

in China were always considered an important channel of communication between the transcendental and intellectual realms and were, as a matter of course, never subject to intellectual tyranny. In the West, conversely, a bias towards the rational, reasoning faculties of mind as the highest way of knowing led to extraordinary technological focus and accomplishments, but at the cost of the subjugation of the arts.

While the West had, by the beginning of the twentieth century, come close to ruling the world with its technological command, the arts in China were precociously advanced and fully mature – even if the Chinese were on the brink of losing sight of this, blinded by the dynamic wonders of the modern western artistic revolution. We see Chinese precocity in the arts in myriad ways once we know how and where to look. So it is worth examining some of them in a bit more detail.

An advanced aesthetic culture tends to develop artistic formats and modes of painting which facilitate the crucial exchange in art, the process of communication between artist and audience. This is very apparent in the Chinese tradition. As early as the mid-sixth century the art historian and critic Xie He suggested six canons of painting in order of importance. Since the originals were each written in only four characters, there is room for some interpretation of his intent; but the first is generally taken to mean spirit resonance, or vitality. That

would equate to an essential combination of vision and its expression with utter confidence through lofty control of the emancipated languages of visual art. The second refers to sophisticated brushwork, implying also the belief in the prime importance of expressionistic brushwork, meaning personality and, again, vision. Matching reality (a reference to subject matter) isn't even mentioned until we get to the third and fourth canons.

The language of line in Chinese art is paramount and immensely subtle. The art of calligraphy in China is so important to the culture not primarily because of what it says – that is largely subsidiary, lexical meaning – but because of *how* it says it. Thus generations of calligraphers can all write out the same famous texts and, in the language of line, all say something different. Such aesthetes do not look at the line in a fourteenth-century painting as depicting part of a cliff and think to themselves 'Mmm ... nice cliff!' They follow the brushwork, they dance with the lines, they become steeped in ink structure (wet/dry, dark/light, fast/slow); they can barely stand still, so exciting an experience is it. Watch linear cognoscenti looking at calligraphy and you'll see them moving, hands, limbs, entire bodies as they follow the movement in the lines – visitors to an exhibition of cursive calligraphy resemble participants in early morning *t'ai chi* in the park. They reflect a quieter variation on the irresistible urge to leap out of your seat and dance at a

rock concert. I've yet to see crowd-surfing at an art exhibition, but I wouldn't rule it out as we become involved with our arts more effectively and efficiently and start to unlock their almost infinite potential.

The Chinese also developed materials and formats centuries ago to facilitate and knowingly enhance efficiency in artistic communication. They evolved a range of highly sophisticated papers, brushes, inks and colours. They did paint on walls, but preferred textiles and, eventually, delicate but amazingly responsive papers. In the West the idea tended towards imposing an idea on a relatively rigid surface, whether gesso on a wall, wood panels, a canvas, or stiff, relatively unresponsive parchment or paper. In China from centuries ago, the materials were designed to dance with the artist, to invoke magic in the process, so that it never became fixed, encouraging continual vitality. The Chinese artist constantly strove through these sophisticated media and tools for control of the uncontrollable. Absorbent papers and ideally flexible brushes with thick bodies and tiny points encouraged partnership with the medium rather than dominance of it, facilitating the discovery of spontaneous magic; but also encouraging efficiency in art's primary role of revealing inner meaning.

Differing formats did the same thing. Long, vertical hanging scrolls and handscrolls, in particular, allowed flexible, shifting perspectives. The Chinese artist was

not primarily interested in precise renditions of the way things looked, so single-point perspective, beloved of the western scientific mind, was unnecessary and unnecessarily restricting. By the twelfth century, critics were already talking of painting things the way they looked as being a childish pursuit. But perhaps the most telling format is the handscroll, one of the most popular formats over the past millennium. Handscrolls evolved out of ancient written texts on strips of bamboo, strung together and rolled up, but began to emerge as a pictorial format two millennia ago. These scrolls, like hanging scrolls, could be looked at, then rolled up and put away, thus keeping the process fresh and vital.

Audience techniques that we encountered in chapter 5 are an essential part of the handscroll experience. The viewer has to look at a section at a time, constantly controlling the composition in a dynamic partnership with the artist. It is rolled up to the right as it is unrolled to the left, if going through it in one direction, although the initiate will often then return in the other direction, concentrating on a different inner language and discovering an entirely different experience of the work of art. The fence between artist and audience is broken down by the process as the audience becomes fully and vitally involved.

You can't really bounce off a handscroll the way you can bounce off a hanging painting. Many paintings,

hanging in the same place for long periods of time, are in danger of becoming functionally invisible as art to those living with them and are mainly revitalised through the eyes of visitors being impressed by them (and perhaps causing a quick ego-boost: 'Good heavens! Is that Van Gogh's *Irises?*').

The handscroll is my favourite format, and I have collected and painted many of them. I have also introduced hundreds of people to them over the past few decades and the result is nearly always the same – complete absorption in the art at levels previously missed, often unimagined. Whenever possible I have asked these inductees days, or weeks later, which paintings they remember hanging on the walls of my home. As a rule they might remember one or two, particularly if we had discussed them, but they wouldn't remember much detail: 'the one with the black strokes and the green bit was nice'; 'there was one with heavy, dark trees – beside the dining room table.' But they never forget the handscroll experience. They can remember the painting in detail – its impact was so much more powerful *because* they had been encouraged to fully participate, to travel through it as an alternative world and become an integral part of the process, recognising and 'reading' its inner languages.

Another indication of an advanced aesthetic culture is the reverence in which it holds its artists, and how those artists are identified and recorded. People admire their

work because it is *theirs*, not because it is *work*, so artists rise above anonymity and begin to appear in the literature. In China we can trace this reverence for recognised painters back to the Han dynasty, two millennia ago. Even then, great artists were cultural heroes.

Have you ever wondered why all those important, ancient Chinese paintings have additional inscriptions and seals all over them? When serious Chinese paintings first appeared in the West, this seemingly vandalistic blizzard of accretions puzzled its new audience. It took the form of bright red collector's seals or appreciative responses written in ink, often directly onto the surface of the painting, sometimes even obscuring part of the original image. To a mind that views the physical work of art as the end product and sanctifies it as such, this seems like vandalism. But to the Chinese aesthete, to whom the physical work of art was not the end product of the process and for whom the audience played a vital role, what was more natural than to allow the audience to actually participate if they felt aesthetically confident in doing so? The *process* was sanctified, and taken very seriously, but the physical work of art was de-emphasised and seen as open to continued creative response, even to the point of actually changing it. As a rule, these accretions were added by other artists and scholars, including emperors who formed or inherited major collections over the centuries. In addition to being one of the most

prolific Chinese art collectors, the eighteenth-century Qianlong emperor was also one of the most prolific 'elegant graffitists' in history. He did not confine himself to inscribing paintings; he wrote poems and colophons to be added to ceramics, jades, musical instruments and a vast range of other works of art that he admired.

Such elegant graffiti constituted positive, sensitive additions made within the same aesthetic and by people from the same group of aesthetes who created the original art objects, or for whom they were created in the case of ceramics, jades and so forth. They kept the process alive. They were, and continue to be, indefinite joint-works potentially involving any future aesthete with access and sufficient confidence.

But what about when someone daubs paint on Carl Andre's bricks or scrawls a message on a Rothko in the Tate Modern, as Vladimir Umanets – Vlad the Inscriber? – was able to do? Vlad's action was immediately hailed as vandalism, despite his claim that he was *adding* to the work of art, not vandalising it. He compared himself to Duchamp, rather missing the point that Duchamp owned the *pissoir* he transformed into art; not to mention that in the Chinese tradition, no one broke into another collector's home and wrote all over his paintings. He either owned the work and added to it as his right, or was invited by the owner to add to it because of his artistic credentials. 'Yellowism' as Umanets called his

'movement', is a typical outcome of a misunderstanding of what has been achieved in the modern western revolution in the arts. One can only hope that if Yellowists ever issue a manifesto for the movement they won't sneak into the National Portrait Gallery with a concealed magic marker in order to do so.

My point here is that while we have emancipated art in the West in our recent revolution, we have some way to go before we fully understand what we have achieved; and thus before we can take full advantage of it in making the process infinitely more efficient and enlightening. But understanding how to do so is an increasingly pressing matter. As I have noted previously, we may be able to emancipate consciousness as well, which could only be beneficial. I believe that process can be accelerated by looking at the arts of cultures that were more precocious aesthetically than the West in certain important ways. China certainly fulfils that criterion.

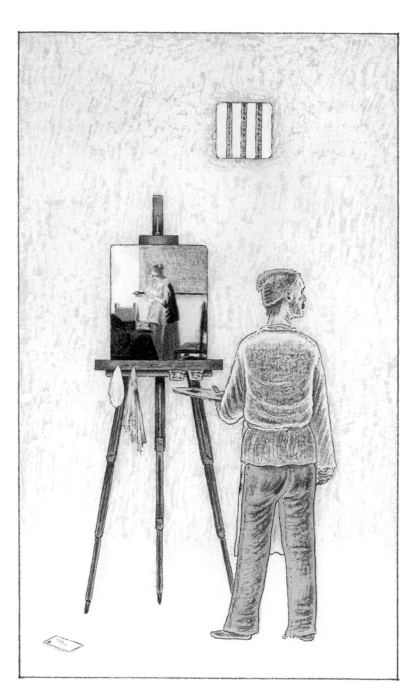

11

relative authenticity

I pastiche, I quote, I lie. Fake, forge, forage,
fabricate, copy, borrow, transform, steal. I illusion.
I'm a genuine deceiver, a shy sham artist.

Shawna Lemay

It's not where you take things from,
it's where you take them to.

Jean-Luc Godard

There ought to be a Nobel Prize for plagiarism.

Jean Renoir

Challenging conventional wisdom is seldom a rapid or simple process. It can take years for well-established beliefs to give way to new ideas, however fallible they may have been. As we have seen, the shift from product-based to process-based aesthetic theory overturns a number of apple carts, and one casualty in particular is the question of authenticity. Process-based aesthetics raises the intriguing possibility of an idea that is utterly counterintuitive to most

observers of the art world – that of relative rather than absolute authenticity.

I once discussed this idea with a friend who is one of America's leading art valuers. It was met with a dismissive snort of derision, and one of those looks I have become accustomed to over the years as I refined my theory of art. I bravely continued, trying to explain why I considered it viable, but she was no longer listening, having (justifiably, I thought) returned her attention to a rather fine plate of shellfish at a harbourside restaurant in the town of Ibiza.

Within the constraints of product-based aesthetics, of course, where the physical work of art is the end product of the process, then every art object is either authentic or it is not – even if we don't know which. Her position, from the perspective of an art valuer faced with a physical work of art, was eminently sensible. If the art object is considered the end product of the artistic process, or you are valuing an art object, then authenticity is a simple, binary issue – your object is either genuine or fake. There is no room for wishy-washy qualifications. But with a shift to process-based theory, with the art object de-emphasised and the communication front and centre, greater flexibility is not just allowed but positively encouraged. In this context, relative authenticity becomes not just possible but entirely sensible. There is no reason why many elements, and much of the meaning, of the original

work of art cannot be carried by a copy; or indeed by a wholly invented work in the style of another artist.

A simple thought experiment will quickly pierce initial doubts about this. During the Renaissance, paintings were often produced partly or wholly by workshop assistants, sometimes in multiple versions of the same painting – some untouched by the master's hand and displaying indistinguishable levels of skill.[*] Let's imagine that an original, important Renaissance painting was destroyed in a fire in the seventeenth century and all that remained was one of these workshop versions. We would still be able to enjoy many aspects of the original, and the painting itself would still be valued as a work of art. From the workshop version we would, for instance, know the composition, symbolism, iconography and other surface details fairly accurately. We could take the copy as evidence of the original in a study of known works by the artists. There might be some minor, subtle differences in painterly skills, but the main difference would relate to the art object and its value. But even the diminished value of the art object bears consideration for what that really implies.

[*] We see a modern reflection of this phenomenon in Andy Warhol's Factory works, an honest, revolutionary response to changes in the nature of art. More recently, the almost industrial output of Damien Hirst is a similar response.

Let us further entertain the possibility of three copies of a particular, lost Renaissance masterpiece: one by the artist's studio, produced as a second version at the time; a second done in the seventeenth century; and a third painted in China yesterday by one of many highly skilled copyists producing facsimiles of masterpieces. (In 2015 the Dulwich Picture Gallery did just this. It hung a £70 Chinese copy of a Fragonard among its collection of genuine masterpieces, challenging visitors to spot the fake. Only one in ten correctly identified it.)

The market value of the three copies would differ widely. The workshop copy would be the most valuable, being closest to the original – possibly indistinguishable from it – and, therefore, relatively the most 'authentic'. The seventeenth-century copy with the advantage of considerable age would be the next most valuable, while the brand-new copy would be worth, well, £70, until the cost of such Chinese copies increased at source. It is likely that the workshop and seventeenth-century versions would also have acquired the patina not only of age, but of exhibition and provenance, passing through the hands of various collectors or institutions. A good many of the separate aspects of the process, therefore, would be satisfied – the meaning, the message of the physical work of art carried successfully. Most elements of the languages of art would be, at least in the workshop copy, almost indistinguishable from the original, including subject matter and

formal, linear, colour and textural qualities. Even confidence and sagacity would be conveyed to some degree, probably significantly. So even if the physical object is not the original, a good deal of relative authenticity remains.

The rational mind would like something to be either genuine or not, but art is more complicated than that. The process, with its manifold and often invisible aspects, is far less susceptible to certainty than the isolated art object. Once again we cling to outdated values in believing that the art object defines the art and that authenticity is therefore a simple black and white issue. And we do so even as we begin to nod respectfully to certain aspects of process aesthetics that make sense of our modern revolution, even if we are only just beginning to understand it.

Han van Meegeren famously fooled the early twentieth-century art world with his forgeries of Vermeer, amongst other artists. At his forgery trial in Amsterdam in 1947, he pointed at one of his works (*Emmaus*, a masterpiece of deception that took seven years to complete) and proclaimed:

> *Yesterday, this painting was worth millions of guilders and experts and art lovers would come from all over the world and pay money to see it. Today, it is worth nothing and nobody would cross the street to see it for free. But the picture has not changed. What has?*

Good question, Han! Our intrepid forger eventually came clean to avoid being convicted of collaborating with the Nazis, after a masterly fake (passed off on Hermann Göring, no less) was traced back to him after the war. During his trial, Van Meegeren was transformed from collaborator with the Nazis, facing a death sentence, to a national hero in the Netherlands for putting one over on them. He was sentenced to a year in prison, which he never served – he died while being considered for a pardon from Queen Wilhelmina.

Today his works are neither worthless, nor are they discreetly hidden away in museum storage racks. Indeed, a 2010 exhibition was devoted to his fakes at Rotterdam's prestigious Museum Boijmans Van Beuningen. So we can no longer dismiss his works as meaningless fraud. Having mastered the style of Vermeer, he invented his own range of subject matter, much of it pretending to be missing links between Vermeer's early and later works – in effect, he channelled Vermeer. He was able to assume the spirit of the artist to such an extent that he fooled experts and museums all over the world, much to their eventual embarrassment.

Van Meegeren's motives were, in many ways, highly artistic, and his methods highly creative. Early on in his career, he was largely ignored by his antiquity-centric peers and felt that his skills as an artist were not gaining proper recognition. Once he had chosen fraud as his

route to fame, he committed himself to it relentlessly and impressively. We'll return to the implications of his status at the end of this chapter, but from the point of view of process-based aesthetics, where the spirit and sagacity of the artist play such an important role and the physical art object is de-emphasised, there is a very good case to be made for his works to be seen as relatively authentic Vermeers – even if the objects themselves are unquestionably fake. The objects fake, the art relatively authentic; intriguing stuff.

We can take this a stage further with an art form that might even convince the Intellectual Tyrant to grudgingly entertain the concept; Chinese calligraphy. It is worth taking a minor detour here to look at what calligraphy really is, and why it is relevant to the subject of relative authenticity.

In Chinese calligraphy, as we have pointed out already, the text itself is incidental. Calligraphy is *art*, not a lexical exercise. That art rests in the brushwork; the formal and linear expression of the artist's skills, training, vision and character. Although primarily formal (how the characters are arranged as individual ideograms and in relation to each other, regardless of the chosen script) and linear, the languages of colour and texture are also important. Colour is expressed in the infinite range of tones obtained from ink and water, texture by the manner in which the brush is used. A fast, dry brush, for instance,

leaves amid the ink markings areas of untouched, white paper (known as 'flying white'). Texture is also inherent in any markings of ink on paper as the two interact.

The cognoscenti usually dismissed the actual text of calligraphy as peripheral to the important aspects of the work. Most of the texts were known to them in any case, many to the point of having been committed to memory as part of basic education. For them, the art revolved around the inner languages that came into play; the true message rested not in the character itself, but in the character of the calligrapher and his artistic ability to express it. This is no different from any other work of art, of course – it is just easier to recognise it with Chinese calligraphy, and to see in it a validation of the shift from object- to process-based aesthetics.

It is also worth bearing in mind a balletic analogy in calligraphy. Not only are we dealing directly with the 'dance' of the brush, we are seeing a similar depth of commitment and life-long training behind it. No one ever invites an untrained volunteer from the audience to take over the lead role in *Swan Lake* while the principal ballerina gets a leg massage in the wings. A lifetime of rigorous training, utter commitment, sacrifice and pain has gone into that brief, glorious moment on stage in front of the rapturous audience. You have to train for years to become a top ballerina, and you have to have the 'right stuff' in you to begin with.

Exactly the same applies to calligraphy. My dear, departed friend Fang Zhaolin, an important twentieth-century Chinese artist who was also a leading calligrapher, practised nearly every day the scripts that she had mastered by training since childhood. She practised many kinds of script. On one of my frequent visits to her studio, she told me that she had decided to start taking lessons in one ancient script she had not yet mastered, from the older artist and master calligrapher Rao Zongyi (Jao Tsung-I). She was in her eighties at the time.

In calligraphy, the training process involves first learning the characters – thousands and thousands of them – and the stroke-order in which their often complex series of lines and dots are written. Then one begins to master writing them perfectly, elegantly, fluently, in regular script. Once that fluency and elegance is achieved, the foundations for branching out into cursive scripts are laid, and the calligrapher follows a similar process until they too are mastered. Now things get really tricky. Next, probably, comes grass-script, the wild expressionistic script beloved of drunken monks, hermits and scholars – too difficult for all but a small clique of scholars versed in its brevity to decipher. Then, perhaps, seal-script, the ancient unifying script imposed by Qin Shi Huangdi upon the warring kingdoms he conquered to create the Chinese Empire in the third century BCE.

And so it goes on. Half a lifetime later, if one is

precocious, one begins to pare away the unnecessary skills so long in the mastering, strip out the frilly bits and reduce brushwork to its bones, its essence. Many calligraphers lack the character to do this and rise no further, clinging to their overt skills as crutches so hard earned they are unable to cast them away. Others simply do not have the visionary breadth for the task. The great calligraphers distil their talent and skills in the alembic of lofty character, constantly stripping away surface cleverness to reveal the inner content, the bones and sinews of their art. You can read that loftiness in the brushwork; you can read the language that allows you to unite with that greatness of spirit, absorb the commitment and sagacity. It's a heady brew.

All of that is a preamble to the fact that the concept of relative authenticity has been an integral part of Chinese art for centuries, with some of the most prominent examples being found in calligraphy. One of the most famous pieces of calligraphy in all of Chinese culture is *The Lanting Preface*, composed and written by the calligrapher-sage Wang Xizhi in 353 CE.

The original text was a preface to a collection of poems written by many of the notable literati of the day, during a drinking game at a Spring Purification Festival. It survived into the Tang dynasty (618–906 CE), when it came into the protective care of a monk called Baincai, who had inherited it from his teacher. In response to

three attempts by emissaries of the emperor Taizong to acquire it from him, he maintained a lengthy pretence that it was lost. Finally the emperor despatched one of his censors, Xiao Yi, disguised as an itinerant scholar, to befriend Biancai and coax him into revealing the truth. He finally brought the treasure out from its hiding place in the roof-beams of his home to show to the censor, who immediately revealed his true identity and confiscated the work for the emperor. Taizong, in turn, decided to 'take it with him' when he died, and according to the legend it was buried with him.

By that time, however, several copies already existed, both traced and copied by eye. These were themselves subsequently copied, some of them being engraved into stone so that rubbings could be taken and disseminated. I have in my own collection a mid-Ming dynasty rubbing taken from three different, still more ancient, versions of the text engraved in stone, together with a rubbing of a copy of an eleventh-century pictorial representation of the original Lanting festival gathering. It is mounted as a handscroll, with a frontispiece by Prince Yi for whom it was compiled.* Some early copies were attempts to

* I wrote more extensively about this in *Arts from the Scholar's Studio* (Gerard Tsang and Hugh Moss, 1986, pp. 66–9, no. 28).

precisely reproduce every aspect of the original; others were by artists rewriting the original text, following its style but signing their own name. An early surviving version of this latter type by Feng Chengsu also dates from the Tang (at some time between 627 and 650 CE) and is currently one of the treasures held in the Palace Museum in Beijing.

Even rubbings from later centuries command both respect and a high value, and one could argue that – just like our imaginary workshop copy of a Renaissance masterpiece, or its seventeenth-century copy – some value would be justified in any case because of their antiquity. In the case of the Palace Museum scroll, that value is justified because of the signature of the well-known calligrapher; and in the case of the rubbings, perhaps just as fine early examples of that form. Few would be as highly valued as art, however, were it not for the importance of the prose and the way it is written. A significant part of their value as art rests in the fact that they carry some of the spirit and the sage character of Wang Xizhi, and what his essay means within the culture. The relative authenticity of the later copies is a vital part of their appeal.

Stepping outside the visual arts, of course, we find incontrovertible confirmation of this in music, ballet and other theatre arts, all the time. Nobody calls Brahms's Piano Concerto No. 2 a fake because the old boy himself isn't seated at the piano; similarly, no one would claim

that The Beatles' version of 'Yesterday' was the only 'authentic' one, and that the other hundreds of interpretations were all fake. There are many other examples in many other arts. It is impossible to be intelligent without learning from the past; it is part of the point of culture that we do so. It is impossible to become an artist while being unaware of anything that has gone before – other than as an intellectual conceit, perhaps, or as the premise for a novel or a TV series (but even Mork wore trousers). All art incorporates plagiarism to some extent.

Proof of that comes from a delightful literary example, something which could only have arisen from our recent western revolution in the arts. In 'Pierre Menard, Author of the *Quixote*', a story written by Jorge Luis Borges and first published in 1939, an imaginary author rewrites *Don Quixote* word for word from his deep knowledge of the original, and presents it as a new piece of literature. This is pure, utterly intriguing conceptual art, raising all sorts of pertinent questions about the nature of art which needed to be raised at the time; but also, now, about the nature of relative authenticity.

Understandably, the Intellectual Tyrant prefers to have his hand on a binary switch: yes/no, black/white, genuine/fake. But as we shall see in the next chapter, in the context of art that may be the equivalent of stepping into a car, facing the wrong way, and asking 'Where am I going to put my herd of cows?' One of art's essential

roles is to reach beyond definition, and the limitations of binary decision-making.

With all this in mind, what should the status of fakes in the art world really be? It is clear from the Van Meegeren story that his paintings were seriously good and that his commitment to fooling the art world was seriously creative. He had to overcome all sorts of physical problems, for one thing. Oil paints take years to harden, and tens if not hundreds of years to attain the characteristic surface degradation and patina of antiquity. Through lengthy experiment, he found a way to mix Bakelite with his pigments before cooking them to achieve the hardness and crackle of ancient paintings. Then he covered them with layers of ink, washing them back to simulate centuries of atmospheric accumulation. He sought out ancient canvases, and made all of his colours in the same way as painters did in the seventeenth century. He constantly experimented, both stylistically and scientifically; at one point even with a pizza oven, although he found after a few burnt paintings that it was better suited to pastry than patina.

He was by no means alone in his endeavours. Wolfgang Beltracchi got away with forging twentieth-century masters for two decades before being exposed, and there are dozens of others with lower profiles. (The very best of them will have no profile whatsoever, of course, a successful forgery business being somewhat

dependent on anonymity.) The world's museums are said to be crawling with unacknowledged fakes. It was once said (I paraphrase, and the numbers are arbitrary) that there are 700 genuine Rembrandt paintings in the world, of which 1,500 are in America.

In a parallel world of my own, that of the Chinese snuff bottle (to which great swathes of forest have been sacrificed over the years to my writings on the subject), there is the famous case of a group of signed and dated bronze bottles dated to the earliest years of the Qing dynasty, 1644–1911. They were broadly accepted as our earliest and, therefore, rather important examples; but having espoused their authenticity for years, even argued vociferously for it, I flip-flopped a few years back after a detailed study of the entire range, to convince myself and the rest of the snuff bottle world that they were actually rather clever late nineteenth-century fakes.

Han van Meegeren and Wolfgang Beltracchi got away with their deceptions for decades. But our cunning snuff bottle forger did even better. He fooled the art world, albeit a tiny corner of it, for the best part of a century. Perhaps, in light of our shift in perspective and a better understanding of the various aspects of the art process, we should accept the inevitable and allow forgery as an art-form. Logic suggests that we should have an aesthetic statute of limitations – since any faker who gets away with fooling the art world for ever (and there must have

certainly been some, if not many) by definition gets to be considered on a par with 'real' artists, why not grant at least part of that status to anyone who gets away with it for a few decades?

Like it or not, forgery is certainly a creative response to experience and, in the case of Van Meegeren, a convincing one that carries with it a good deal of relative authenticity. As the art critic Emily Genauer wrote, 'Perhaps we are almost at the point of sophistication where we are able to enjoy a work of art for what it is.'

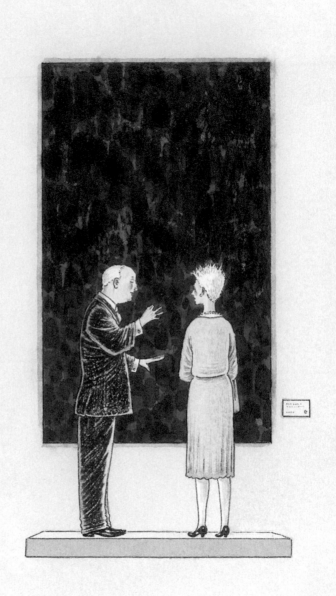

12

all the fun of the fair

I don't like most contemporary art. But I think if
you talked to any person who's heavily involved in
contemporary art, they'd say the same thing. If you go
to a biennale, you don't expect to like much of it.

Grayson Perry

Few people in contemporary art demonstrate much curiosity.
The majority spend their days blathering on, rather than
trying to work out why one artist is more interesting than
another, or why one picture works and another doesn't.

Charles Saatchi

For many of us, the search for works of art that we
can enjoy – or at least try to – takes place at art
fairs. These are now so important as vehicles for
the acquisition of art that they deserve a discussion of
their own, as they neatly and visibly encapsulate many of
the ideas we've discussed so far.

Contemporary and modern art fairs can be daunting
prospects, to say the least. It can be overwhelming to
encounter dozens or even hundreds of temporary galleries

filled with a great deal of work that we will inevitably find puzzling. It is all too easy to be swamped by the tsunami of intellectual and visual stimulation concentrated in one place.

Many of the wealthier collectors these days are shepherded through the unwieldy assault on the senses by their so-called 'art advisers', who lead them directly to the nuggets of meaning in the infinite matrix of blah. Art advisers have done their homework. They keep abreast of the contemporary art world, they know which artists have 'the buzz' and, critically, they keep track of the all-important price levels. These should not be so low as to suggest that they are unimportant, nor so high that they are obviously overpriced – and therefore too risky a punt in the marathon race for contemporary significance which very few artists end up even finishing. The finishing post is a good few years down the line, and a great many of the artists exhibited today will be forgotten, slumped by the wayside by then. Others will limp across the line, but perhaps several years after the winners.

Making the right bet here is in some cases a matter of spending enough money. I know one contemporary collector in Beijing whose advice is not to bother with anything under US$100,000, as the serious increase in value is from that point upwards. Below that figure there are far too many works by far too many artists, which drastically lowers the odds of finding a potential winner.

Never mind the painting, check out the price tag. It is a deeply suspicious maxim, of course, and one that may hide for a wealthy collector a lack of confidence in his own judgement, but there can be no doubt that the serious art tends to end up where the serious money is.

Many other factors are at play here. As discussed earlier, the process of art includes the process of audience recognition and appreciation. This in turn creates a somewhat circular dynamic, where a group of influential galleries, auctioneers, art advisers, consultants and collectors are in a position to shift the limelight – as long as they agree broadly on where it should be shining. Part of the art adviser's job is to make sure (in so far as this is possible) that the buying process is relatively authentic, even if they are part of it – based on genuine admiration for the right qualities, rather than on the fact that some influential player has a warehouse full of the artist's entire output to date and an iron-clad contract for everything produced in future.

The average art aspirant, however, will have to manage without a dedicated art adviser, and will not have special access to the people and resources that advisers offer. (Indeed, the art advisers will have made sure that the serious top-end buyers have already been offered most of the real goodies before the mere VIPs even get through the doors.) Most art lovers won't have that $100,000, either. But there's no reason why any of that should

prevent you from enjoying and profiting from art fairs. Here, then, is a guide to approaching the dizzying (and, if you are planning to buy, potentially dangerous) world of art fairs.

The first rule is not to take any of it seriously enough to either upset or confuse you, at least up to the point at which you reach for your credit card. Treat it as a game in which you are offered multiple opportunities to follow a few among thousands of possible paths, none of which is right or wrong until you decide that it is.

Start by roaming slowly. It doesn't matter where you start – just look at each stand as a whole initially, taking in the overall impression of the artworks on display and of the stand itself. The moment either a stand or an individual work of art catches your attention, treat that as your first 'path' and focus on it. If you look even vaguely promising as a buyer, you will almost certainly soon be accosted by a member of the staff – often a junior gallery member, whose main task is to winnow the thronging crowd as they, in turn, winnow the art. If you look particularly promising (or it's been a very bad fair) you may even get the gallerist taking you in hand personally. Their approach will usually be either a charming, disarming one designed to convince you how likeable and trustworthy they are or, if you are less fortunate, a barrage of art-speak that gets straight down to the business of flogging you that particular work of art. 'Fascinating

what he can do with the banal components of a tea-set, eh?' Or 'The positioning of the cigarette, of course, is intended as an ironic hint as to the futility of clinging to every-day addiction when isolated from reality as art and deprived of an upper torso by the artist.'

(If you enjoy such conversation, by all means let 'em rip. Bear in mind, though, that while they are ripping, you are probably not going to be able to focus on the work of art; you will be hearing *about* the object, not dealing with the work of art itself. All well and good, in the right place and time; but for now, remember that it is the eyes you are trying to train, not the ears.)

Once you have politely shooed away eager sales-folk (and after endless hours at endless fairs, it is the 'politely' part that I find a challenge), stand in an optimal position in front of the work of art and try to block out everyone and everything else. This is admittedly tricky at fairs, where sensitivity is as lacking among the audience as it is among a great deal of the art; you are very likely to have a stream of tourists stroll noisily between you and a painting, or someone who will stand right in front of it blocking your view. But if you're interested enough in the art, you'll find a way – much of this is like meditation, in that you just have to practise rising above the chatter (whether of the crowds or the intellect).

Once you have a decent view, it's time to consider what to actually look at. It makes sense to focus first on

the most accessible languages of the object; again, we'll deal with the languages of visual art for convenience.

If there is overt subject matter of some kind, however obvious, start with that. See if it interests you either for its obvious content; whether self-evidently calm, harmonious, or meant to shock, for example, or for any hidden meaning that can be intuited without being explained. Does it still intrigue you? If the answer is no, it's clearly time to move on. But if your attention is still grabbed, it's time to move on from the language of subject matter to the inner languages – initially form, line, colour and texture.

Grasping form is about understanding the work's composition; for example, how the artist has arranged various shapes on the picture plane, and how blocks of colour are juxtaposed. Don't be afraid to step back or move in closer to get a better view of any aspect. Distant and close-up views offer different opportunities, but each adds something different to your analysis of the work.

Now turn to line. Look first at how lines in the painting define separate areas, effectively serving form. It's worth noting here that you will quickly lose the initial urge to precisely define and separate different languages – you only need to do so in order to become initially involved with them. Eventually the intention is meditational, in effect; the aim is to rise above the intellectual definitions of separate languages, and to experience the

art wholly and directly. But in order to do that you need the tools of intellect; among which are analysis of the lines in front of you, and your knowledge of line in art generally. For instance, Mondrian's lines in his mature, geometric abstracts are primarily an extension of form, their main role in his later classic works being to define and separate shapes. Jackson Pollock's lines, on the other hand, are more independently expressive.

Isolate the more obvious lines, following the movement of the brush. See how confident they are, how dynamic and independently exciting. You will soon get very caught up in this. If the gallerist returns and asks you please not to dance on his stand, you will know you have mastered the essential lessons of the language of line. Then you can hit him with 'I was just unconsciously responding to the inner turmoil and vitality expressed by the artist through his knowing use of the "phoenix-tail" movement of the brushwork in the outline of the dustbin. It's as if every line were contained in its own etheric sheath. Left-handed artist, I presume?'

Next: shift your focus to colour. This may seem like a language that is fairly obvious and speaks largely for itself, but in fact the trained aesthetic mind can find infinite depth in any of the languages of visual art if it focuses and allows itself time. An experience many years ago on a cross-Channel ferry to mainland Europe on a grim, grey day served as a useful lesson to me of the potential for

colour. I would have described the entire scene as 'grey' had anyone asked, and boringly so. But then I spotted bobbing in the waves the blue plastic top of a discarded bottle. As a relief from the grey, and because of its bobbing progress past the bows and along the side of the boat, I stared at it for longer than I might otherwise have done. Suddenly I started seeing the various shades of blue emerge from the previously dull grey continuum. They seemed endless. Everywhere I looked, the clouds and sea seemed to be separating into various subtle shades of blue. Then I focused on the vessel I was standing on, and the damn thing hit me with a howl of different blues that would have impressed B. B. King.

Experiencing this for yourself is simply a matter of getting involved. Switch off all the other languages in your mind and just focus on the colour. Pick the dominant one and see how the artist has used it, perhaps as a main colour statement with counterpoints elsewhere in the picture. See what other colours have been balanced with it, and where they crop up again. Soon, you will see the whole thing as a symphony of colour, rather than individual colour notes.

It's time for texture. This is rather difficult at first, unless the artist has mixed paint with gravel or painted (perhaps even painted *with*) a huge sponge. It's sometimes obvious in its own right, but it is more often found as part of the other languages. Every time you add a brush

full of colour, you add texture. When ink bleeds into absorbent paper, the overall effect becomes textural. As you progress, you will very quickly see that the distinctions between the languages begin to blur.

Once we've dealt with the five principal languages of art, we're ready to seek out other important inner languages. I have mentioned confidence on several occasions, and I bring it up again here as it is easier to recognise and judge than sagacity or wisdom. Note that I am not saying that there is necessarily a hierarchy in these languages. There is no particular hierarchy in the various aspects of the overall process of art. Some kid off the streets can be overflowing with confidence, splishing and splashing with wildly expressive markings, yet still create banal nonsense if lacking a command of other essential languages; or without real purpose for creating the work of art, or any level of wisdom to express in the first place. We adore the uninhibited works of children, but they end up on the refrigerator door, not in museums and evening auctions (or any auctions at all, unless the kid grew up to be Picasso or Tracey Emin). We don't expect wisdom from a four-year-old, however confident the markings; and ultimately it is wisdom we seek in art, or at least a boost in understanding that leads us to it.

Once you begin to really focus, language by language, you'll soon learn them all without any difficulty. At any point in this exercise, if you should come across something

you consider banal, or you don't like the subject matter or any other aspect of it in any language, abandon it and select another work to focus on. You are in a perceptual candy store, but you don't have to eat every sweet in every jar; moving on is an essential part of the process of art from the audience's point of view. As you learn the languages, you begin to recognise banality and admire sagacity in what is being 'said'. Your consciousness is being enhanced through the exchange with the languages of art. It's worth saying that this is neither an arduous nor lengthy process. If you have grasped the theory and try this approach you can, quite reasonably, expect to leave the ranks of the bewildered by the time you have spent a couple of hours in a single art fair.

Some of the things that look like languages of art turn out to have little depth. One good example often encountered in vast quantities at art fairs is 'punchline art', where there is an immediate message or reference to something which is clever or funny; but once you've got the joke, or the reference, what then? You can't listen to the same joke over and over again and still find it amusing. If you were to buy the work and take it home, you could show it to others who, on their first encounter, might find it briefly amusing too; but again, then what? Art needs something more, some profundity of inner languages, some weight in other parts of the process, if it is to attain any aesthetic longevity.

This is not to say that punchline art is automatically

banal, of course; but it is always worth checking for something else that will give it lasting appeal. A really brilliant punchline, of course, can cause ripples in the art world. Picasso's saddle and handlebars rearranged as the head of a bull (*Bull's Head*, 1942) is a masterly piece of punchline art. Like Duchamp's *Fountain,* it was important because it changed the way we looked at art at a key moment in art history. It was similarly the cause of demonstrations against it, to the point of it being removed from an exhibition as a result. On its surface, it was a brilliant punchline. But it was also an astonishing, powerful piece of sculpture exquisitely evoking its subject, while making no attempt to hide the found content of its construction.

The next exercise I recommend, just to bolster your morale and to recognise the efficiency of this learning process, is to revisit the few most moving works you encountered. Pick your top five (if you found five that moved you at all), and go back to look at them again with your newly trained eyes. See which of them still resonates, still passes the test – you will often be surprised at how much you have learned in the intervening time just by applying yourself to the languages one by one in a measured, analytical process.

To this end, if you are permitted, take photos of each work you found satisfying after the analytical process; then, when you revisit them, compare the photograph to

the painting. The all-important inner languages of art are de-emphasised by photography. Photos pick up primarily the obvious subject matter, formal arrangements and so on – but few of the inner subtleties. It is a standard rule, and a very useful one – to which, incidentally, I have never found an exception in my particular field of Chinese paintings – that if the photograph looks better than the painting, it is because the inner languages are disappointing. If the painting looks better than the photograph, it is likely to be stronger in these inner languages. If you have selected a group of potentially interesting works from the illustrations in an auction catalogue, for example, but find them disappointing in real life (usually the case with a significant proportion unless it is a major sale of particularly notable works), then they are not great paintings. Still, studying them to discover exactly where they fail is a useful exercise; and a great painting by a lesser artist will always be more rewarding than a bad painting by a more famous one.

If you've come this far, you may now be thinking that this analytical process is in direct contradiction to my entire theory of the process of art. That would miss a vital point. The intellect, with its inherent capacity for analysis, is an essential tool in the evolution of consciousness; something to be honed and transcended, not rejected. It is only the tyranny that we need to reject. Once the tyrant is dethroned, his steely stare replaced by a benign

smile and a helpful demeanour, the intellect is of course a delightful life companion. This kind of analysis leads, eventually, to the capacity to transcend all the distinctions – and it may well happen on your very first attempt to delve deeply into the full experience of art, where you suddenly find yourself completely lost in the work, transported to a timeless realm, all distinction between you and the art temporarily suspended, as happens frequently in the musical experience. That will be a major step forwards, a glimpse of the transcendent possibilities to which art can lead – but don't lose any sleep if it doesn't happen right away. If it happens it happens, and it will be delightful, possibly enlightening (or even Enlightening, you never know). In the meantime, going through the exercise is, in itself, entirely worthwhile in any case.

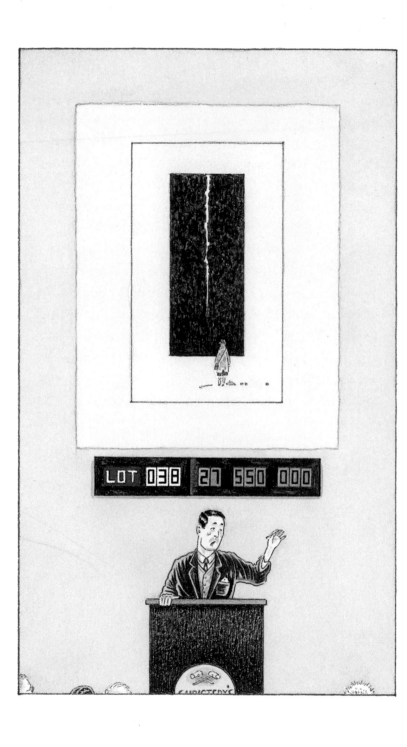

13

in at the deep end

Sex is like art. Most of it is pretty bad, and the
good stuff is out of your price range.

Scott Roeben

So far we have been talking about learning how to
approach art rather than buying it, which is invari-
ably a much more dangerous process. While we are
safely on shore and not yet stepping gingerly on to the
ice, there is a further stage you might find useful, espe-
cially if you currently lack the funds to buy what you are
admiring: becoming a virtual collector.

Start at an art fair by photographing your top choices.
Don't be greedy – just shoot those that really impress you,
not everything on display. Ask their prices, the names of
the artists, date of the work, and so on. Then go home and
gather as much information about the artists as you can
find. Study their other works. Perhaps keep a computer
database of your selection and research into the artists.

Do the same in galleries and at auctions. At auction,
once you've selected the works you really want, fix a price
you will nominally bid. Follow the auction carefully you

can usually do this online now, and in a few years it will be standard practice to do so. If one of the selected works makes *more* than your nominal bid, don't enter it in your virtual collection; but if it makes *less*, do (don't forget to include in the cost that cheeky little item in the small print, the buyer's premium). Importantly, limit yourself to a viable budget, even when dealing with nominal bids. It will be no challenge, and far less useful as an exercise, if you imagine you have endless funds to spend.

This process will give you far greater insight into the works of art you have selected as meaningful. As you do all of this, you will automatically improve your aesthetic judgement. You will decide that some artists you had selected don't quite cut the mustard. Their other works may be too repetitive or much less exciting; their backgrounds, age, published statements, lifestyle, attitude et al. may give you pause to wonder about their real insight or importance. Dispose of them from the 'collection', perhaps filing them away so you can keep track of progress over time. Every time you do that, assign a 'sales' value – what similar works are selling for at auction or in fairs, what you might reasonably expect to have sold it for had you really owned it – and add it to your budget for future purchases. You can value those you are keeping every year or so too, on the same basis, just to keep tabs. This is a practical aspect of the game which becomes useful mainly when you stop playing and get involved in

a real collection. It is very handy to be able to see then how far behind or ahead you would have been financially had you been buying these works of art. It will also show you where your greatest triumphs and mistakes would have been, giving you a better chance of repeating the first and avoiding the second.

Finally, once you gain a little confidence, and if you have the money, do it for real. At this stage, there are inevitably some more rules. A useful guiding principle is simply this: never rush. There really is no hurry, especially in contemporary art. There will always be plenty to choose from, and you are much better off taking your time and buying with confidence than being pressured into a purchase you may regret. You will hear, time and time again, variations on the theme of 'You'd better buy one of these quickly, as they are going up like a rocket,' 'This artist is really hot – if you don't buy this one, I doubt you'll ever get another,' or 'She only produces ten paintings a year, so if you'd like to leave me a deposit, I'll see if I can manage to get you on to the waiting list.'

Listen to everyone, take it all on board, filter out the bullshit and find out where the really useful information is coming from. Then make up your own mind based on the confidence you're building over time. Until you have that confidence, don't buy anything. An alternative, although not entirely without risk, is to have confidence in a dealer or auction expert, or other art adviser. There

is no doubt that some of the finest collections have been formed through partnerships between savvy, wealthy collectors and knowledgeable, reliable professionals, but that involves some initial risk; you can just as easily misjudge the integrity of a dealer as you can the value of a painting if you don't know much about either.

A second rule, whatever you are buying, is to agree the terms up front. First of those, of course, is the price – art, unlike cans of baked beans, does not come with a 'recommended sale price'. The main gauge of value is auction prices, coupled with a broad swathe of gallery prices. Bear in mind, though, that auction prices represent a momentary value based on a number of variables; just because one painting by an artist makes an unusually high price, that is no guarantee that all the rest of his paintings will (or even that the same painting will hold its value the next time it goes to auction). An auction price can be based upon two wealthy egotists with money to burn competing against each other, neither wanting to lose face. If one had decided at the last minute not to bother, the price might have been a quarter of what it eventually made. Also bear in mind that if the previous buyer puts the work back into auction, he is eliminated as a potential buyer.

Markets are like a pyramid; the higher you go, the thinner the structure, and a good deal of the top end of the art market is distinctly narrow. Human nature

dictates that there is a tendency for everyone involved in selling art to be rather optimistic about value. Price, other than at a reliable auction, will always be negotiable. If you can cling to the belief that you are in no rush, you are in a strong position to begin with. If you have decided you'd like a painting by so-and-so and you see one you like, be willing to make an offer without embarrassment at a price you think is fair. You can couch it in the sort of terms a dealer hates to hear, unless it has been a really lousy fair businesswise, which are along the lines of: 'I like the painting, but I don't *have* to own it and am in no hurry, so if an offer of x interests you, I'm happy to pay that. If not, fine. Have a think about it and give me a ring if you'd like to accept it.' Once you are more familiar with the artists, their values, your taste and your eagerness to acquire serious works, by all means pay the asking price if you have to. But make sure that *you* are the one to decide that, based on your own knowledge and confidence.

Once a price is agreed, make sure you get a full descriptive invoice with all the details of artist, medium, size, date, condition, provenance, exhibition history etc., and agree with the dealer that if the information turns out to be wrong in any material aspect, you can return the painting and get all your money back. You will eventually come to trust a small group of professionals, so it is worth establishing early on the rules by which you will play. (One good reason for doing this is that once you do

establish relationships with reliable art advisers, dealers or auctioneers – and of course with the fellow collectors whom you will inevitably meet along the way – you will find they are also a great source of knowledge, which you can soak up to augment your direct approach.)

A simple exchange of emails should suffice to agree terms. You don't really need a lawyer, although if you are spending very large sums you might prefer to have one draw up a contract of some sort. Such a move may be seen as impugning a dealer's integrity and might be considered offensive, but if you are sufficiently wealthy most professionals will soon overcome any hurt feelings. Any decent dealer who has integrity and is willing to take the long-term view should not object to this initial requirement and your wish for a safety net in a strange new circus. Auction houses already have pages of small print in the back of the catalogue which cover all this, of course, usually overwhelmingly in their favour, but at least it's already down on paper.

The really important thing is to minimise pressure and angst. They are of course entirely unnecessary as an enthusiast or virtual collector, and fully containable as an actual collector. Never forget that you are a vital part of the process of art; and, from your point of view, the dominant part at the point where you apply yourself and focus attention. Don't act, even towards yourself, as a neophyte struggling to understand mysteries forever

beyond you; instead, see yourself as the judge and jury of art, even if you are not the executioner – since you are unlikely to be buying one of your own works at a fair.

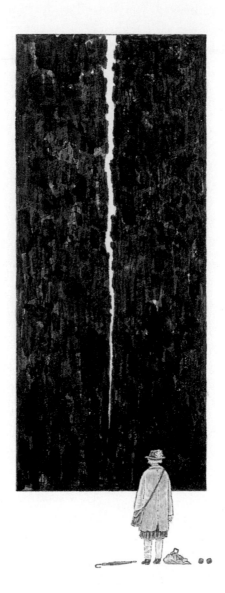

14

befuddling the intellect

The only thing that matters in art is
what cannot be explained.

Georges Braque

It should have become clear by now that the intellect
is an essential component in the understanding and
appreciation of art, whether we are considering
aesthetics or authenticity, even if it must be transcended
to fulfil the process. My own view is that conscious-
ness has a goal, and that we must pass through *all* of the
stages of experience to reach it – from the most primor-
dial to the most intellectual, in order to achieve the
transcendent, enlightened state. But it is by no means
necessary for anyone to agree on what the ultimate goal
of this process really looks like in order to grasp the role
of art.

For some, it is enough to allow that art really is one of
the primary vehicles in the evolution of our conscious-
ness, without worrying about what happens when we get
to the end of the process (or, indeed, if there *is* an end
to the process). Others may find it easier to think of art

simply as something that gradually enhances the intellect as we absorb it. I believe that the latter view may inhibit the efficiency of the evolution of consciousness, but it won't adversely affect the potential of art in our lives. All we need recognise is that the process of the evolution of consciousness is served by the process of art – a neat reminder of the usefulness of devising a theory of art and consciousness rather than a separate theory of art.

For the purposes of this chapter, however, let's throw caution out of the window and entertain the idea that my theory is viable; that we should be focusing on transcendence in order to tame our inner intellectual tyrant and attain a higher level of consciousness. One key aspect of this is what I call befuddling the intellect – the transcending of our exquisitely honed logical, analytical mental processes in pursuit of a higher perspective. Art, in its highest role, is one of the tools that helps us befuddle ourselves and reach the highest level of our consciousness.

The process of all transcendental forms of meditation – and I refer here to far more than the method derived from ancient Vedic tradition in India, subsequently appropriated by Maharishi Mahesh Yogi – involves befuddling the intellect in order to transcend it. Such befuddling is necessary because it is often impossible to resolve problems at the same level of consciousness that gives rise to them. As we know to our cost, that just leads to ever more complex problems and conflicting

ideologies. Over the millennia, consciousness has evolved through the resolution of paradox, as we move from one level of intellectual understanding to the next. A single example serves to illustrate this. We once believed that the Earth was at the centre of the universe; then shifted to the belief that the sun was at its centre; and finally came to the conclusion that in fact our entire solar system is no more than insignificant space debris, just one among untold billions. Each progression in understanding was prompted by apparent paradoxes arising from our previous assumptions.

Eventually, however, the paradox of the intellect itself arises, and it is prompted to transcend itself as the only meaningful next step. It is the fundamental purpose of the Zen *koan* to point this out to the aspirati. 'What is the sound of one hand clapping?' or 'Show me the face you had before you were born' are not meant to be answered literally; they are intended to demonstrate that language, and the rational realm of the intellect where it holds sway, are inadequate alone, and that such puzzling, paradoxical questions can only be dealt with by cranking consciousness up to the next level. Such paradoxical questions are signposts to a channel of communication between the intellectual and trans-intellectual realms of consciousness.

In its role as a high-level tool of communication serving the evolution of consciousness, art too must ultimately provide a channel of communication between

these two realms. This is why so much of the process of art has one foot in the realm of explication and one in the transcendent, inexplicable, undifferentiated realm. One of art's most fundamental tenets is precisely that at its highest levels, it plays an important communicative role beyond the specific – while at the same time offering more specific meaning too. Art can multi-task.

It is the very complexity of this process that makes it so efficient, once we approach it knowingly. As we are drawn into the languages of art, moving from the surface to inner, more esoteric languages, they become increasingly difficult to follow analytically. The intellect finds itself led into a realm where it can no longer adequately cope; it reaches the limits of its capacity and becomes befuddled. That, ultimately, is the role of art; to finally befuddle the intellect, having first helped to put it through its paces and hone it to the limit. At the highest level, art helps to persuade the intellect of its own limitations, encouraging it to seek a higher perspective and efficiently fulfil its proper role in the evolution of consciousness.

As our intellect becomes befuddled, all sorts of new experiences become possible – in particular, those undifferentiated experiences that come so easily in music but are equally accessible in any art form. Art, in that sense, and at that depth, is highly meditational – as good a path as any other towards enlightenment.

What are we looking for on that path? Ultimately, we

seek maturity, sagacity and depth of understanding in our arts. Once we find them, we can begin to hear the inner languages of art infinitely more clearly. We can begin to see that the rules we thought governed art no longer do. Until we reach that highest level of consciousness, art is just a channel of communication – a means to an end. It is something with *function* in our lives at many levels, as we saw in chapter 3. Once we reach that level, though, art is transformed into something with no need for actual purpose – pure delight, perhaps to be capitalised now as Art. But even when we have reached the stage where art serves no practical purpose, we still always have the choice to return our gaze to its other functions, freed of our need to see them as demanding of anything at all. The final stage of art appreciation is pure delight; but like the zenith of the calligrapher's art, the road to that delight may be long and winding.

It is worth reminding ourselves that nothing I propose negates the intention, vision or technical ability of the artist. Nor does it deny the importance of the physical work of art, or the role of the audience, or any of the other lower-level roles of art. All of these are crucial parts of the process, and worthy subjects for separate attention – in that respect, nothing has changed. The point is that the ultimate role of art is as a vehicle, and as such it might be useful to consider an analogy with a more conventional form of vehicle.

A car may be styled for aesthetic appeal and be worthy of attention for that alone; it may have a masterpiece of mechanical science as its engine; it may have the comfort level of a very expensive armchair, and the sound system of an Ibizan discotheque. But to work efficiently as a vehicle, we eventually have to fire up the engine and go somewhere. Its ultimate role is to get us from one place to another – from where we are to where we want to be – as efficiently as possible. Art is precisely the same, but in terms of consciousness. Where we are is the intellectual realm of consciousness; where we want to be is the trans-intellectual realm. Art is the vehicle that will take us there.

appendix
conversations with the lizard

So far, I've kept the difficult transcendental stuff to a bare minimum, mentioning it only in passing to make a point. Here, for anyone intrigued by the nature of Enlightenment, are a few more of my own thoughts about it.

Before we get started, bear in mind that any rationalisation is dependent upon the intellect, which cannot successfully explain what lies beyond it any more than science can explain what lies beyond the known universe. The difference is that the transcendent realm is knowable, just not adequately explicable; what lies beyond the universe is neither.

To begin at the beginning: let's assume the existence of a source of all things – the universe, consciousness and anything else we can perceive. Let's also leave this source undefined, to avoid conflicting ideology and all its inherent dangers. Its whole point is that it is undifferentiated, untainted by intellectual prejudice, and lacking self-recognition or the capacity for delight, since these are entirely human concerns, of course – it took the

existence of a universe seeded with the ingredients for intelligent life, and a lot of time, for the capacity for any such concepts to evolve.

If the universe 'began' in any sensible way – and there is of course still some disagreement about that – then the Big Bang seems the likeliest of current theories about how it happened. Attempting to define anything before the singularity is meaningless; it represents the beginning of time as well as of our universe and is, in any case, unknowable to human intelligence. So let us see in the source *potentiality*, both in physical terms (as in a potential universe even if not yet realised), and in terms of consciousness (potential consciousness, again even if not yet realised).

Exactly how it all began is not crucial to our approach to the evolution of consciousness. All that matters is that the universe provides a stage for it. Whatever the process involved, it led to our known universe with its galaxies, stars and eventually life on Earth, which then evolved to produce the intellectual capacity of the human mind. We don't actually even need to know how we arrived at that point; it is simply enough to know that we did. We may consider the potentiality for consciousness as being fragmented on the stage of time at the birth of the universe which, as it cooled, gradually coalesced into ever more complex units to form first the environment for life, then life itself, consciousness and eventually self-consciousness.

The uncountable billions of overlapping processes by which consciousness evolved are clearly far beyond the scope of this book. But it is nonetheless helpful to distil them into three key stages that will help us to understand Enlightenment.

Prior to the advent of intellect, consciousness was in a state of unconsidered harmony with its environment: an age we might describe as 'Primordial Harmony'. Existential concern was absent and living creatures, even if hungry or threatened, did not ponder their state; they reacted instinctively. Once full, or safe, they settled back into comfortable, unthinking harmony with themselves and their environment.

The advent of intellect (defined here as the rational, reasoning faculties of mind) saw the birth of the second phase, an age we might describe as 'Intellectual Disharmony'. At some point consciousness evolved to the point where a star-gazer could realise that the gazer was separate from the stars, and that each could be considered independently. With this realisation came the capacity to distinguish between things; to name them, record them and communicate their existence to others. Individuals were able to recognise their individuality and selfishly plan for its benefit, creating an environment for disharmony, both with the self (unfulfilled aspiration, fear of the future and of death in particular) and with others. Thus ego was born; and consciousness evolved from a

harmonious state into a disharmonious one, as part of its essential evolutionary path. Angst is the price we pay, and must pay, for intellectual intelligence. We can track the progress of the intellect from the most basic means of communication and record-keeping to today's internet; it is an exponential expansion of intellectual capacity and the means of communicating it.

The final transformation, the Enlightenment experience, represents the beginning of the third and final stage, which we might term an age of 'Reacquired Harmony'. In this stage, we return to experience the unified state of the source but carrying with us the vital, hard-won intellectual capacity to make sense of it all and to appreciate and delight in it. The use of the word 'final' here might seem to indicate a short-sighted approach to currently unimaginable future developments. The third phase, however, takes us beyond any such intellectual concepts as 'final', 'future' or 'unimaginable', making them all meaningless in this context. The intellect will always find new ideas, but the whole point about the Enlightenment experience is that it must be grasped whole, undifferentiated, and outside time and place, so any concept of an improvement on it is equally meaningless.

As the intellect began to develop, individuals were still able to reach back into the unified, pre-intellectual state of primordial harmony. Initially the two were so close that no significant journey was involved. Intellectually

capable beings would have initially slipped from one state to the other unthinkingly, before the distance became great enough to become an effective barrier. The more the intellect developed, the further away it moved from primordial harmony. Its capacity to understand and its delight in reacquiring that harmony became greater, but the difficulty of doing so increased.

In the earliest phase of intellect, returning to the unified mode was easy, but also relatively meaningless. As the intellect became more powerful and more dominant, the separation became more distinct and the distance greater and harder to travel; but the reward for returning knowingly to the undifferentiated state exponentially increased, because our capacity to understand and interpret it was constantly being enhanced. At the same time, however, as the intellect became more powerful it began to flirt with an illusory autonomy, beginning a subtle process of denial of any higher mode of consciousness: enter the Intellectual Tyrant.

I believe that the need to reach back into this realm of harmony and unity is inherent in humanity. Regardless of intellectual denial, we still tend to reduce our longing for it to a series of metaphors and analogies to stand for what we have lost – quite apart from our religions mirroring this need, it resonates in myths and legends worldwide.

I am reluctant to dabble in the concept of purpose in the evolution of consciousness or indeed anything else

on a cosmic scale, since it is an intellectual concept –
and therefore a product of only one very recent phase of
the broader evolution of consciousness. It seems to me
that it is a human need to extrapolate our intellectual
capacity and expect purpose as a governing principle.
The moment we assume some purpose we must at least
flirt with religion, even if not jumping straight into bed
with it. Religion, it seems to me, depends on a circularity
of argument in which we backdate our own recently
acquired intellectual capacity and vest it in some higher
power from which we then presume to be derived; the
higher power then being paradoxically diminished by a
whole slew of very human aspirations and rules.

It seems much more likely that out of a countless
number of possible universes, but in any case in our own
for certain, things just worked out the way they have.
One planet just happened to be hospitable for life, and
a series of biological accidents subsequently produced
intellectual consciousness. According to the current
multiverse theory, an infinite number of other universes
would have failed to produce life; similarly, thousands
upon thousands of other species in *this* universe failed
to survive the random, chaotic, violent processes that led
to our present world. I'm not sure we should take it any
more seriously than that, although a little gratitude to
accidental circumstance might be in order – perhaps, one
day, an international holiday to celebrate chance?

The same flow of events, of course, can be interpreted in a number of different ways to satisfy a number of different perspectives. Indeed, that is the role of the intellect: to interpret experience, hence different perspectives, or ideologies in the first place. The *point*, which is also the message, is that the interpretation is not the important part: if we can transcend the realm in which intellectual ideologies are granted greater authority than they deserve, we can begin to move beyond the dangers of the age of Intellectual Disharmony.

And what of Enlightenment? In my theory, the three stages in the evolution of consciousness are matched, rather neatly, by three phases in the process of Enlightenment: aspiration, realisation and integration.

Aspiration is when we recognise that there is something worth attaining. This aspiration to Enlightenment makes the process more efficient, in the same way as identifying a destination before embarking on a journey makes travel more efficient; if you are travelling for a purpose, that is. It also allows us to do what I had done unknowingly, which is to understand enough about it to be receptive when it happens and not divert it to some ideological end.

Realisation is when it happens, the Enlightenment experience itself. The timing of this is random; it happens when it happens. There is no explicable formula for forcing it, only an attitude that aims towards it.

We must also consider the chemical path to realisation. Although normally excluded from 'nice' books – the Tyrant disapproves of anything that befuddles intellect – many ancient spiritual movements did *not* exclude this, of course. The use of transformative drugs found in nature was and remains common in many cultures; certainly among hermits and recluses in ancient China, where a variety of hallucinogens were regularly ingested in the pursuit of immortality or simply for the joy of it.

There is an intriguing lesson to be learned from the Chinese concept of immortality, where such alchemical use of drugs to transform consciousness was routine. In China, the concept of immortality differs radically from that of the West. It is the act of stepping off the stage of time, as part of the wider Enlightenment experience, that grants immortality by transcending time rather than living in its thrall for ever. How this was achieved was less relevant, in the same way that alcohol in Chinese society was looked upon as a positive relaxer of inhibitions and befuddler of the intellect. The famous Song dynasty literatus and poet Su Shi (Su Dongbo, 1037–1101 CE) was considered to have had a drinking problem: it was that he was unable to drink because his metabolism wouldn't allow it. The Tang dynasty poet Li Bai (701–762 CE), on the other hand, was gloriously and famously drunk most of the time, and no one ever suggested this was a bad thing. In China there was less prejudice than in the

West against munching on a mushroom or downing a jar of wine to encourage an altered state.

Outside the conventional scaffold of time, a second is the equivalent of eternity – so one can literally become immortal in the blink of an eye. This is a far more efficient concept than simply living for ever, the take on immortality that still predominates in the West. (One might have expected the Intellectual Tyrant to notice that, so far, no one has actually ever managed this; other than through rather optimistic ideas about the rebirth of individual personality in an afterlife of some sort.)

Integration is how the Enlightened individual spends the balance of a lifetime applying the overarching perspective to the existential realm of everyday life. Armed with the complete transcendent perspective, the intellect is able to make complete sense of the fragments. This is an ongoing process.

The newly Enlightened return from their experience possessed of extraordinary insights granted by their new perspective. All problems, once seen from this new perspective, become manageable. They still exist at a practical level, and still need dealing with in the everyday world, but unless the experience is subverted by the Intellectual Tyrant, they are de-fanged, transformed. Some we can resolve, some we must just accept, but the point is that no problem remains too difficult to deal with, no burden too great to bear. The dictates of the ego fade; fear

of failure, loss, and even of death evaporate, removing whole swathes of existential angst. The fear of death is removed, simply through the process of uniting with what lies beyond ego-driven individual life and consciousness while still alive. Once one has stepped off the stage of time, death becomes less consequential. It is no longer the ultimate threat, since all death ever threatens to do is to remove us from the stage of time in the first place; but it threatens to do so in a manner that terrifies the insecure Intellectual Tyrant.

The Enlightenment experience grants us the capacity to live more wholly in the moment, with access to the higher perspective. Life becomes immensely more pleasurable and harmonious. This harmony seeps out into society, and as more and more people become enlightened, the harmony spreads. That is the very obvious reason why Buddhist cultures generally tend to be more peaceful and harmonious than those with vengeful, separate gods 'at the helm' – and, of course, always 'on their side' when going to war.

If the Enlightened state became more prevalent worldwide, we would automatically begin to deal more sensibly with conflicting ideologies (political, philosophical, religious), and eventually perhaps even completely tame them. In transition (for the age of intellectual disharmony is a transitional phase), we may still have to deal with yet another deranged dictator who thinks that

genocide, or the sacrifice of half the population he governs for 'the greater good' of the rest (or more to the point, himself), is a sane response. But the point is that were the Enlightened perspective to govern across the globe, the likelihood of such deranged individuals getting a chance at dictatorship would become, hopefully, vanishingly small. Manic egos would be nipped in the bud by sagacity before they could even think of writing a manifesto or raising an army.

We come from the source, we return to the source – it just happens, with no purpose or plan required. It is the bit in between that is the problem, but it is also the bit in between that is as vital to our species as oxygen. We can also claim that bit as the source of art, but there is no reason for it to be confined there. There will be plenty of art in an Enlightened world, and it will be deeply meaningful. It will also, of course, still serve multiple purposes – being both a means to an end in attaining a state of pure delight, and pure delight itself.

endnote

For the discerning aesthete, I can offer, at a modest if otherwise undefined price, an entirely conceptual Forklift Truck – part of a limited edition of an infinite number.

It comes with a blank white label for display purposes.